Drawing **Perspective**

Tim Fisher

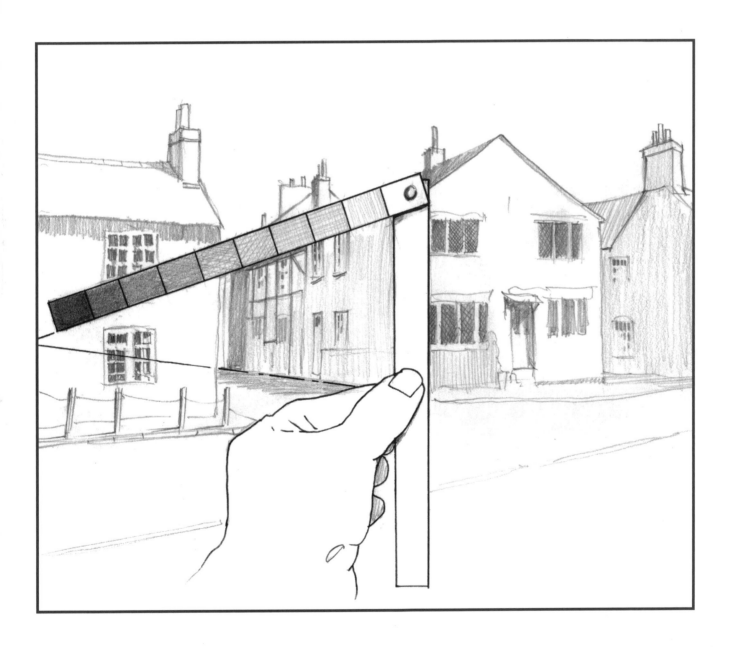

SEARCH PRESS

First published in Great Britain 2017

Search Press Limited
Wellwood, North Farm Road,
Tunbridge Wells, Kent TN2 3DR

ISBN: 978-1-78221-111-2

Suppliers
If you have difficulty in obtaining any of the
materials and equipment mentioned in this book,
then please visit the Search Press website for
details of suppliers:
www.searchpress.com

Acknowledgements
Thank you to Roz Dace for having the faith to
commission me for a second book for Search Press.
Thanks also to my editor, Sophie Kersey, for her
assistance, encouragement and feedback during
the publishing process.

I would like to thank my wife Louise, who tirelessly
helped me to find subjects that were relevant to this
publication, the endless cups of tea, and also her
never failing encouragement that I was heading in
the right direction. A special thank you to our friend
Kelvin Greenberry for his help and advice with
photography.

Finally, to all my students past, present and future,
whose enthusiasm and feedback helps to make
teaching art such a rewarding and enjoyable part of
my life.

Printed in Malaysia

Front cover
The Circus, Bath, UK
This curved structure is one of the many fine architectural examples to be found in this city. The drawing is done on Bristol vellum board in 0.3 black fibre-tipped drawing pen over an initial rough layout in 3B pencil.

Page 1
St Paul's
The drawing is completed in black acrylic ink with a dip pen. Looking back along the gently sloping ground of Peter's Hill towards St Paul's Cathedral, all the lines converge to a single vanishing point somewhere near the heads of the figures in the distance. There is the additional challenge of steps and ellipses in this drawing.

Opposite
Red Lion Street
This drawing was completed with a dip pen and Chinese ink on cartridge paper. Red Lion Street, Stathern, nestles in the picturesque area of the Vale of Belvoir, Leicestershire. A number of villages in this region provide good drawing subjects. I was careful not to over-detail the complex brickwork of the nearer building.

Below
Shire Horses
A quick impression drawn on the spot at a ploughing match using a fibre-tipped drawing pen and sketchbook. The stance of the horses forms a natural square through which vanishing points can be projected.

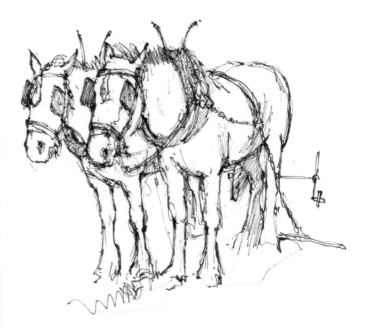

Dedication

To my wife, Louise, who has helped to make my dream a reality and without whom this book would not have been possible.

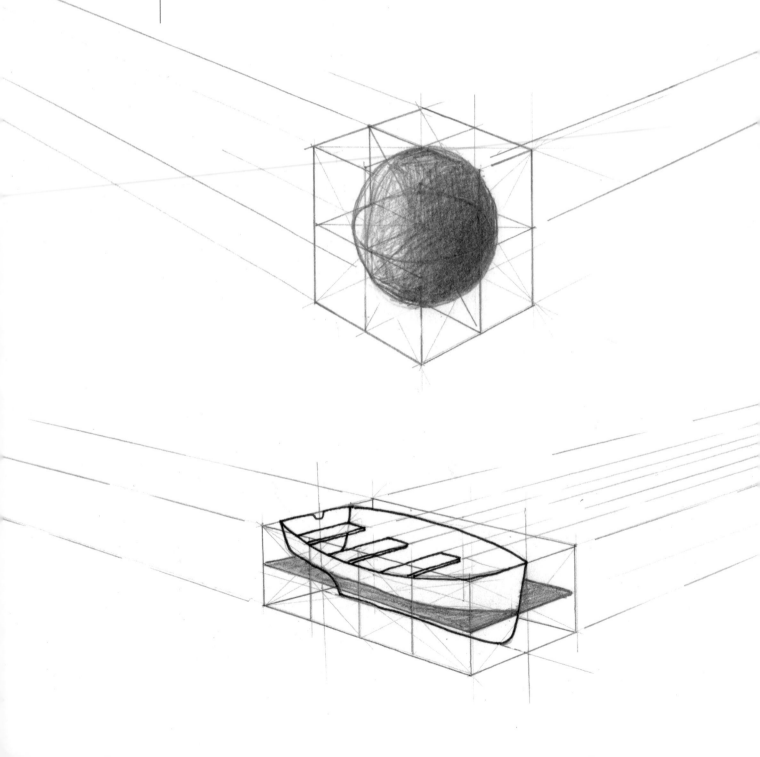

Contents

Introduction 6

The history of
perspective 8

Materials 12

Techniques 20

Zero-point
perspective 28

Measurement,
proportion and
scale 32

Single-point
perspective 34

Two-point
perspective 40

Multiple-point
perspective 50

Varying perspective 54

People 60

Animals 64

Boats 68

Shadows 72

Reflections 76

Skies and seas 80

Inclined planes 86

Curved perspective 90

Common mistakes 98

Beyond the rules 104

Index 112

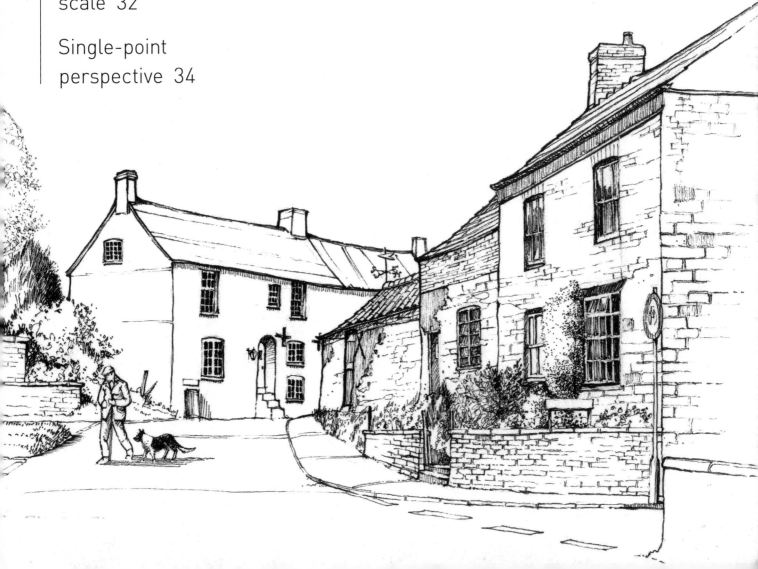

Introduction

Many artists see perspective as a perplexing and puzzling subject. Our ability to grasp the three-dimensional world and form an understanding of it is essential to our ability to draw an image correctly. Anything we see is subject to perspective, some obviously, some not.

Our view of the world is greatly influenced by a perception of objects that we learn at an early age. We quickly build a representation of the universe in our heads and this model will continue to manipulate and interfere with our ability to draw what we see for years to come.

There's an old saying, 'You haven't seen anything until you've drawn it'. Being able to draw what you see is like seeing a new world for the first time. It is a wonderful thing to appreciate a landscape or even how a shadow falls onto steps.

My early attempts at drawing were not always successful, and I see now that I had no knowledge of perspective, and was unaware that it was having a big influence on my work. Things just didn't look right and I didn't know why. This book is designed to help you see and understand the world and how perspective in its many forms has an influence on it. I encourage you to observe and practise freehand drawing regularly and try out the exercises in the book, as it is only by doing this that you will come to understand how things work.

When you are freehand drawing, avoid too much use of an eraser or even a ruler. Live with your mistakes, as it is a great teacher for future work. Rub them out and they are lost forever. Take yourself right out of your comfort zone and use an indelible drawing pen. Ruled lines can look very unnatural when rendering subjects in a freehand manner.

Try not to become too dependent on photographs but draw from life wherever possible. Camera lenses distort and curve the edges of a scene and we unknowingly transfer these distortions into our drawings.

Finally, at the end of the book we explore ways of perceiving perspective without following rules. These techniques have been established since the Middle Ages. Do give them a try – this is a way of working I have used for many years and it really helps the artist to see the world in perspective.

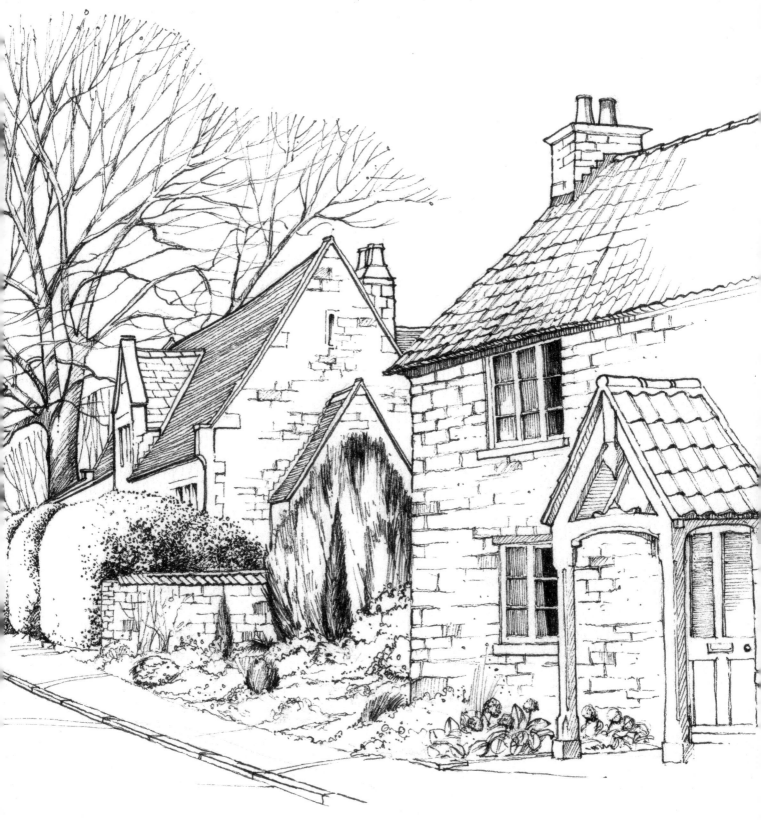

Harston

This is a quiet little village located on the Leicestershire border. The drawing was created with a dip pen and Indian ink on cartridge paper. The pen was ideal for rendering the structural details of the magnificent tree at the end of the street, architectural details and the carefully tended front garden.

7

Materials

PENCILS

Always try to choose a good quality pencil. Performance varies from make to make, and this is often evident when it comes to applying shade. Cheaper leads can feel quite gritty when used and will not always achieve the range of tints required in a sketch. I usually work with a good quality 3B graphite pencil which gives me a wide range of tones when shading.

Alternatively, a clutch pencil can be used into which various grades of lead can be inserted. These can be extended when drawing, making it easier to apply shade from the side of the tip.

Carbon pencils deliver a broader range of tones as the initial mark is quite dark. Apply more pressure and a black shade can be produced; apply less pressure to achieve a wide range of greys. The lines made by these pencils are not as easy to erase as those made from a graphite pencil. I prefer to use the slightly harder 2B carbon pencils.

Tinted charcoal pencils are available in sets and have just a hint of subtle colour which makes an ideal medium for drawing where ease of lifting out using a putty eraser is required.

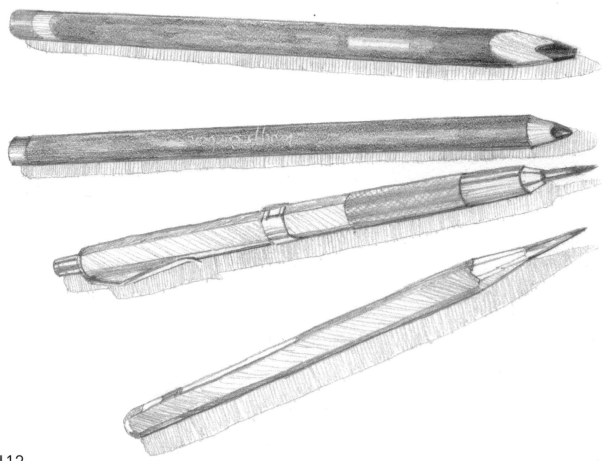

12

Sharpening

Graphite pencils can be sharpened in a standard sharpener with a blade or a helical cutter. All other pencil types will quickly dull a sharpened blade, so that the wooden pencil casing starts to splinter during sharpening. For a better point, long point sharpeners are available. These have two sharpening chambers, one for the wooden casing and one for the lead.

Pencils can also be sharpened with a craft knife or scalpel. This allows the pencil to stay sharp for longer as the side can be used to apply shade. Some types of charcoal pencil are difficult to sharpen to a fine point and sometimes it's easier to create a square tip. Fine lines can be made from the edges.

A long point sharpener.

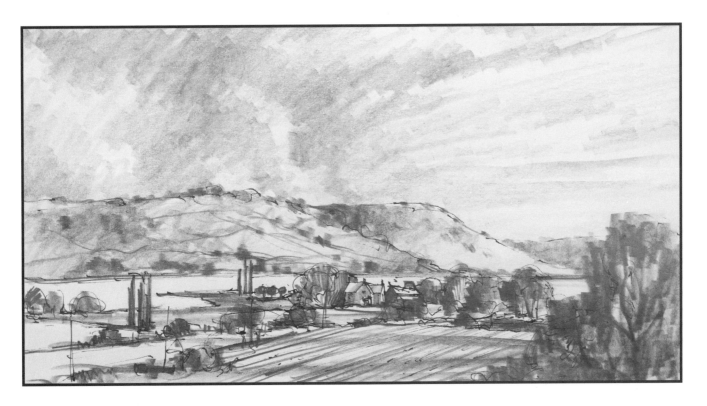

Above: Blagdon Lake, Somerset, UK, drawn using carbon pencil.

Left: Selworthy, Exmoor, UK, done in graphite pencil.

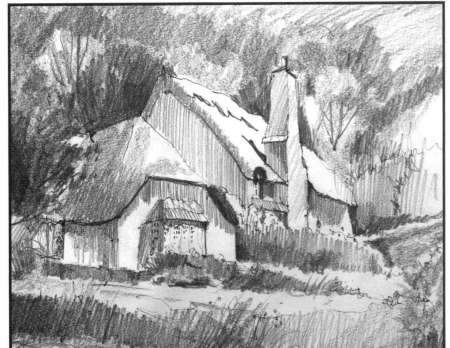

DIP PEN AND INK

Expressive line work can be created more easily with a dip pen and ink. Nibs can be purchased quite cheaply in sets and are often labelled as drawing nibs or mapping pen nibs. A pen holder is also required into which each nib can be inserted. Alternatively, I sometimes use 6mm (¼in) wooden dowel cut to length and hold the nib in place with electrician's insulation tape. This saves the nib getting glued into the holder by dried ink. Inks are available in Chinese or Indian, which are almost identical, and acrylic. Indian inks are carbon-based and contain a varnish which, when dry, creates a waterproof line. Acrylic ink feels slightly thicker when drawing and doesn't always flow so well. Don't allow ink to dry on the pens; it is important to keep the drawing tip clean to avoid unwanted blots or spatter.

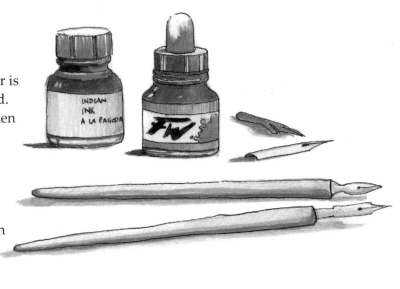

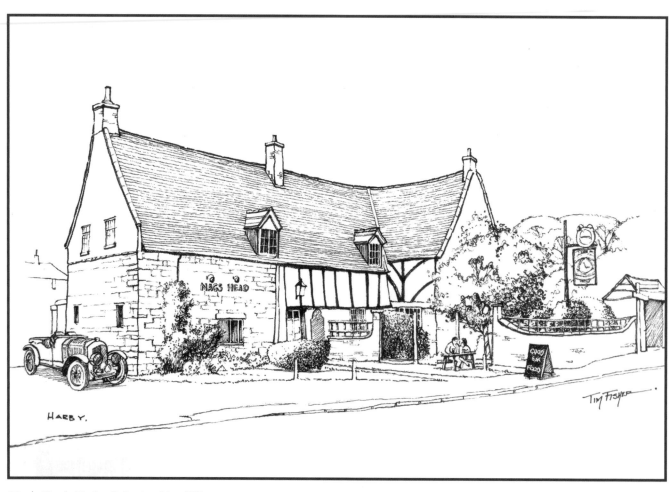

Nag's Head, Harby, Leicestershire, UK.

DRAWING PENS

Fibre-tipped drawing pens or technical pens have opened up a whole new world for the artist. Although first designed for architects and engineers, these pens have found popularity amongst artists for their portability and ease of use. To avoid smudging or bleeding, it's best to start with the ones that contain waterproof ink and are fully lightfast. They come in a range of sizes, 0.1, 0.3, 0.5, 0.7. The ones I use are called superfine, fine, medium and brush. I find that working with the fine or 0.3 tip, I can render the most intricate fine lines to slightly broader marks, making this the best all-round size. Line variety is limited with these pens, so if I feel I need more, I'll move onto ink and a dip pen.

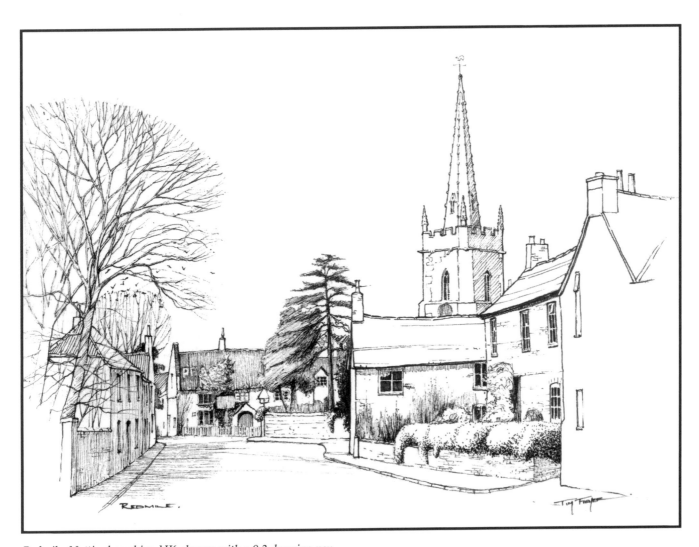

Redmile, Nottinghamshire, UK, drawn with a 0.3 drawing pen.

CHARCOAL

Willow charcoal is available in stick form. The sticks can be broken down into 2.5cm (1in) lengths to work with. A useful technique is to cover the entire paper surface with charcoal and then use a putty eraser to lift out the lighter areas of the subject. This method helps us to see shapes and patterns more easily. The best type of putty eraser is a soft, kneadable one. These can be shaped easily into various forms, so they can be used quite accurately. Charcoal dust disappears as it is folded into the eraser.

The first picture below is of Moonlit Westminster. I removed the sky area around the buildings and then the roadway to get the perspective shape. The vehicles, trees and street furniture were drawn in with a charcoal stick and then light areas such as the headlights and wet reflections in the road were removed to finish the sketch. I blended the edges of the sketch gently with my fingers to vignette the scene.

With the Skelwith Bridge subject, I lifted out the lighter areas to form the bridge and the river. Additional darks were applied later with the tip of the charcoal stick to build up the detail within the sketch.

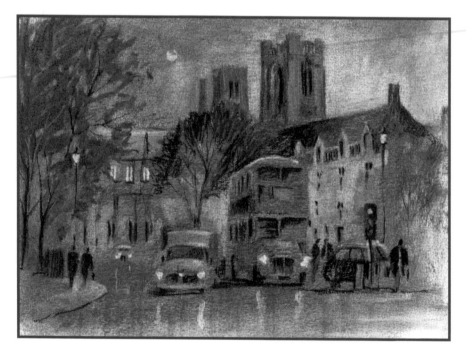

Moonlit Westminster
This night-time London scene was done in charcoal, finger blended and lifted out with putty eraser.

Skelwith Bridge
This drawing of Skelwith Bridge in the UK's Lake District was done in charcoal and lifted out with putty eraser.

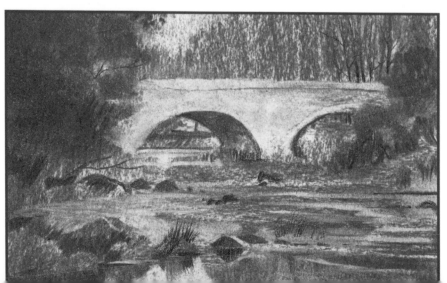

SKETCH MARKERS AND WATER-SOLUBLE INKS

Tone or shadows can quickly be applied to ink drawings to capture fleeting lights using sketch markers. These pens, developed for the Manga industry, contain alcohol-based inks and are available in a wide range of colours including warm and cool greys. They are twin-tipped. The broad tip allows grey tone to be applied over a large area quickly and the fine tip allows for more accurate work. I find them ideal for working quickly out of doors.

Water-soluble inks are another means of quickly applying tone. The drawing can be created with a steel-nib cartridge pen containing water-soluble ink, after which the edges can be bled with a water brush. These handy brushes have a water reservoir contained within the handle, keeping the brush tip wet while you are working. Ink can be picked off the tip of the drawing pen and painted directly into the sketch for broader areas of darker tone.

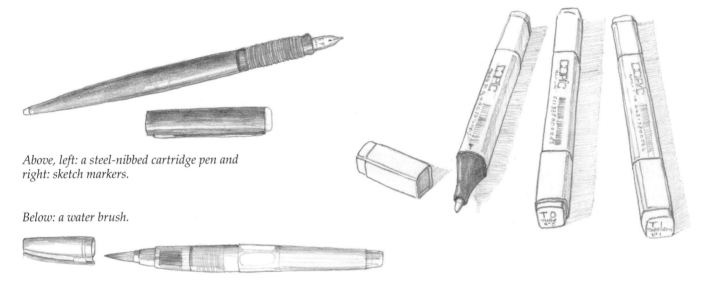

Above, left: a steel-nibbed cartridge pen and right: sketch markers.

Below: a water brush.

Canary Wharf
Another London scene, done in drawing pen and sketch markers.

Barkby
This Leicestershire scene was done in water-soluble ink and water brush.

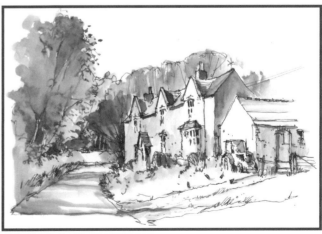

SURFACES

Cartridge paper is one of the best all-round drawing surfaces. It is a high quality heavy paper, originally used for making paper cartridges. It is often found in sketchbooks and should have a smooth surface and feel quite dense. Inferior papers without these qualities can result in ink pen lines bleeding and any graphite applied will fail to stay on the surface and smudge easily.

I also like to work on Bristol board, especially the vellum surface. This provides a stiff, strong surface to work on and takes pen work and graphite shading extremely well.

Another useful paper is laid paper, which has a slightly ribbed texture imparted during the manufacturing process. Surfaces are usually tinted and it is an ideal support for charcoal and Conté chalk. The tint provides a nice middle-ground tone, ideal for highlights when using white chalks. The paper is often quite thin and so a cushion of soft paper such as several layers of newspaper underneath prevents any unwanted marks appearing in the drawing.

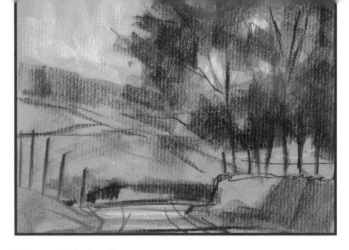

Towards Dolgellau
Conté chalk and charcoal on tinted laid paper.

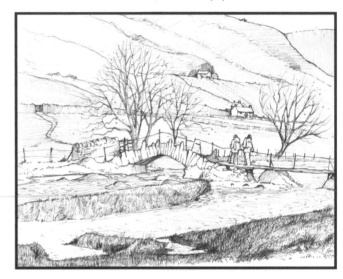

Slater's Bridge
This scene in the UK's Lake District was done in drawing pen on cartridge paper.

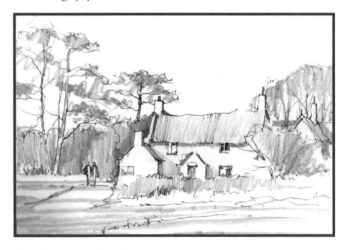

Old Cottage, Shipham
This Somerset cottage was drawn in carbon pencil and ink on Bristol vellum board.

TOOLS OF THE TRADE

A comfortable well-lit working environment is important as well as having a stable surface to draw on. Specialist **drafting tables** can be tilted and positioned to create a good working position.

I have a small collection of **French curves**: plastic templates which help create smooth curves of varying radii. Mine also have a series of ellipses contained within which come in very handy to sort out problems with shapes. A **flexi-curve** is useful for creating even larger smooth curves. It can be easily formed into a number of useful curved shapes.

Compasses are important when working on curved perspective subjects. Where larger radii are required, a beam attachment helps to extend the drawing range.

I have a 45.7cm (18in) shatterproof **ruler** with a small hole drilled either end. Strong thread is passed through the holes and knotted at one end. By pulling the free end, I can bend the ruler, providing a handy curve to draw along.

I also have a plastic **T square** 63.5cm (25in) long. Sometimes, when developing scaled-down perspective drawings, finding the vanishing points still requires a long ruler. A T square is also handy for sliding up and down the edge of the drawing board. Combined with a 45 degree drafting triangle, all the verticals and horizontal guidelines can easily be checked on a large drawing.

A kneadable **putty eraser** comes in handy when working with charcoal or Conté for lifting out light areas in a drawing. I avoid harder, white erasers as these tend to damage surfaces and leave debris.

Shading drawings can result in work being smudged, so I attach a small piece of **clean white paper** to the side of my palm with double-sided tape. A draftsman's **erasing shield** is a thin metal plate with various holes punched through. These holes can be used as a mask to remove unwanted marks without damaging the surrounding drawing.

Blenders are available in various shapes and materials and are useful for introducing variations into your shading or for more accurate work. I work with a small silicone grey cup chisel blender.

I fix my paper to the drawing board with **picture framer's tape**. This heavy self-adhesive brown tape has a glue that will not deteriorate with time like masking tape glue. The adhesive should always be peeled away from the work when you are removing it.

A **perspective finder** is a simple tool made from two pieces of 13 × 128mm (½ × 7in) mountcard, hinged at one end using a brass split pin. This is useful for judging the correct angles when viewing buildings and other structures.

An A3 drafting board with a built-in ruler and 45 degree drafting triangle which I use on smaller work.

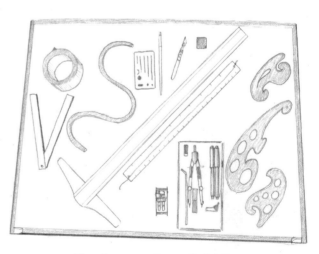

French curves, 63.5cm (25in) T square, 45.7cm (18in) shatterproof ruler, compasses, long point sharpener, putty eraser, scalpel, cup chisel blender, erasing shield, flexi-curve, picture framer's tape, perspective finder.

Techniques

PENCIL TECHNIQUES

Pencils can be purchased in a wide range of grades or degrees of hardness. I find that drawing mostly with a single grade allows me to work quickly and efficiently. Occasionally, when dealing with perspective, I need to work with a slightly harder grade for marking out the relationship between lines as they disappear towards a vanishing point. I would normally choose an HB lead for this. Too hard a lead and there is the risk of indenting the paper surface, which only becomes apparent when working over with a softer pencil, by which time the marks are hard to cover up. For general drawing and applying shade, I use a 3B pencil. A good quality one will give a wide range of tones from near black to very pale shades. If a poorer quality lead is used, darks are much harder to achieve and the medium can feel gritty.

The way the pencil is held is an important step along the path to achieving a sensitive touch when working on a drawing. I grip the pencil between my thumb, third finger and index finger as shown below. Where darker tones are needed, I can add more pressure on to the top of the pencil with my index finger. Using this method, a range of shades from the most delicate to the darkest can be achieved.

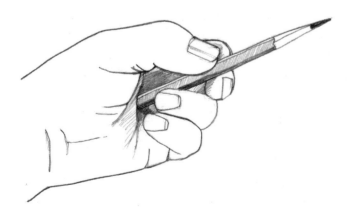

My pencil grip.

The way the pencil lead is shaped is also important as a great deal of work comes from the side rather than the tip. I sharpen the lead with a scalpel to achieve the shape shown below, top. Once the tip shape has been achieved, resharpening is easy. Sometimes it is possible to apply too much pressure when forming the darks. I have found that shaping the tip differently so that the lead is supported by the wood on one side reduces breakages.

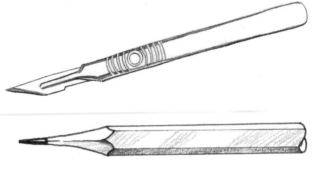

Correct sharpening.

Alternative sharpening to reduce breakages.

Some types of pencil such as chalk-based ones or those with very soft leads are difficult to sharpen to a point (below, top). The charcoal pencil shown below this has been sharpened to a square tip. Two sides are sharpened to a shallow taper and the wood on the other two sides grips the lead and reduce breakages.

Charcoal pencils shown blunt (top) and sharpened to a square tip (bottom).

Making a tonal scale

A good way to try out your pencil handling skills is to produce a tonal scale from white to near black. First draw ten connected rectangles measuring 2 × 2cm (¾ × ¾in). The next step is to shade each square so that the tone becomes progressively darker moving from left to right. The first space is left as white paper, which is always the lightest tone that can be achieved. For the next nine spaces, work from the sharp tip of the pencil and draw a series of vertical parallel lines across all of the spaces. Starting at space 3, draw a series of horizontal parallel lines all the way across to the last space on the right. Starting at space 4, draw diagonal lines from left to right all the way across to the last space. At space 5, start drawing diagonal lines going the other way. At space 6, draw more vertical lines over the previous work, finishing off in the last space. At this point it becomes more difficult to apply controlled line work to achieve different shades. For this reason, starting in box 8, using uniform pressure, shade using the side of the pencil across to box 10. This action eliminates any white paper showing through and the box will look darker. Work over boxes 9 and 10, adding a little more pressure with your index finger pressed against the pencil tip, and these will go even darker. The remaining box 10 can now be worked over using even more pressure. I find that working the lead in a circular motion rather than side to side deposits even more graphite, making the space look quite dark.

A tonal scale made using pencil.

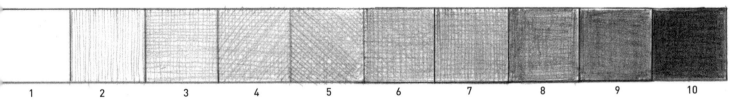

1 2 3 4 5 6 7 8 9 10

When finished, this tonal scale can be cut out and mounted onto a piece of card. The card can be held up against subjects when judging tonal differences, for instance in a landscape. The value scale can be numbered 1 to 10. these numbers can then be added to an ink outline sketch to record values for later use when applying shade.

PEN TECHNIQUES

Ink provides the artist with a stable medium to work with as well as a wide range of marks and techniques to use. The problem is that the mark is permanent and cannot easily be erased. With this in mind, most resort to creating a pencil drawing and then carefully tracing over it with ink. This can be seen in Suffolk Mill 1 where I have drawn over a detailed pencil outline using a fibre-tipped drawing pen and a ruler. The image lacks depth and interest, as all the lines are uniform and of similar thickness. In Suffolk Mill 2 I have tried to work more quickly. Using a 0.3 fibre-tipped drawing pen, the distant trees are represented by a dotted line. The freehand lines on the mill are slightly crooked, adding character to the drawing. I've also created more depth by adding an Indian ink wash to the nearer tree and some line work on the road to represent shadows.

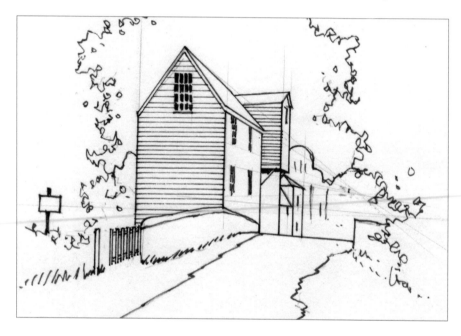

Suffolk Mill 1.

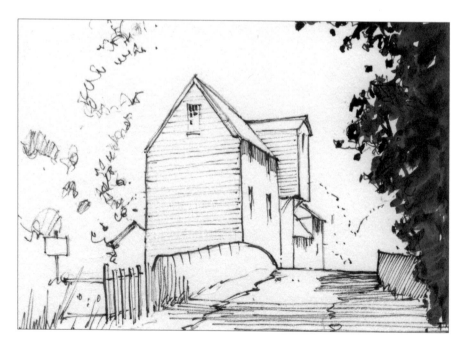

Suffolk Mill 2.

Unfortunately, using the method employed for Suffolk Mill 1, some of the spontaneity of the artist's hand gets lost. I find that holding a fibre-tipped drawing pen differently helps to produce a more interesting ink mark. We instinctively hold the pen the way we learn to do handwriting at school (see below) which can result in a bolder mark.

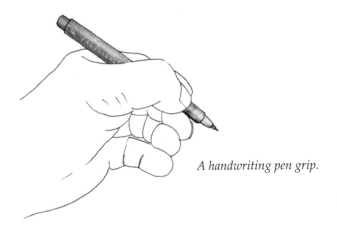

A handwriting pen grip.

I've found that by holding the fingers further away from the tip of the pen a much lighter, flexible line can be produced. Although this method can feel awkward and uncomfortable at first, regular use gives a freedom of movement and line variability that is ideal for ink drawing. The line applied is lighter and finer which makes correction easier, and thicker-nibbed fibre-tipped pens can be used with the same results.

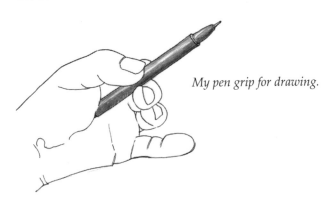

My pen grip for drawing.

When working, most of the time I unconsciously make a continuous line, pushing, pulling and twisting the pen in my fingers, so that the line varies (see below).

I like to put a sense of depth into drawings when adding ink and try to vary the line work to achieve this. For distance I add a dotted edge, as in the tree outline in Suffolk Mill 2, being careful not to make the marks look too regular like a chain link fence (see below).

Nearer marks in the drawing get thicker, which I sometimes achieve by going over the same line twice with the pen (see below). Even here, the line is broken in places to help make the work more interesting.

Tonal effects and textures can also be achieved with a dip pen and ink or fibre-tipped drawing pen. The amount of tone added can easily be controlled by the number of marks made. The square below left shows simple hatching which immediately gives an area in the drawing a sense of shade. Cross hatching in the opposite direction makes the tone progressively darker (below middle). To go even darker, horizontal and vertical hatching can be added (below right).

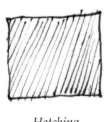 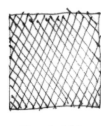

Hatching *Cross hatching* *Cross hatching with horizontal and vertical hatching*

By varying the spacing of the lines, shapes can be indicated with the pen marks. This method works well to represent curved surfaces (below).

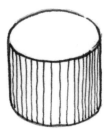

By stippling, bushes and foliage can be represented (see top right). Experimenting with different marks and combining them can be useful for indicating complex textures within undergrowth (see lower right).

A number of these line making techniques can be seen in Bottesford Cottages (below). These marks were all made with a steel nib dip pen.

Stippling

Undergrowth

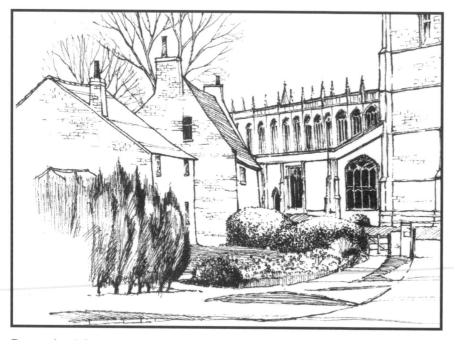

Bottesford Cottages
These cottages in Leicestershire, UK, were drawn with a dip pen.

A different type of line can be achieved using a dip pen. In this sample, right, I have varied the pressure of the pen nib to create a number of different line types.

In the sample right, middle, I've used a damp brush pen to flick ink from the pen nib onto the paper. Using liquid inks gives access to an almost infinite variety of tones from very dilute greys to near black. This is ideal for adding shade to a drawing (right, bottom).

Another way of adding shade is to use tonal markers. I like using the sketch markers which come in a good range of grey tones as well as other colours. I have used just two tonal markers, toner grey no 1 and toner grey 0 in the sample shown below, left, to achieve four different shades of grey. By holding the pen in contact with the surface or working more slowly, more pigment flows into the paper, making a darker mark. The darker marks can be seen again in the sample shown bottom, right, where I have paused frequently with the marker.

OTHER TECHNIQUES

I find that combining ink drawings with pencil is one of the quickest ways of adding shadow and body to a sketch. This sketch (right) of Maltings Yard, Exton, Rutland in the UK, started off as a rapid ink drawing. Working quickly, I indicated the boundaries or format of the sketch as I worked. This one was starting to take on a square outline. Once this stage is complete, more shade can be applied from the side of a 3B pencil (see below). I do this on the spot or, if the weather is not too good, retire to a dry place to add the tone later. I often 'imagine' the lighting conditions, as working this way can conjure up some interesting compositions. Here I represented some of the distant shadows on the building by a series of vertical, parallel shaded lines. In the nearer ground I worked from the side of the pencil. For the tree on the right, I applied more pressure for a stronger dark to add depth to the work.

A pencil sketch of Maltings Yard, Exton, in Rutland, UK. It was started in ink, then completed with pencil.

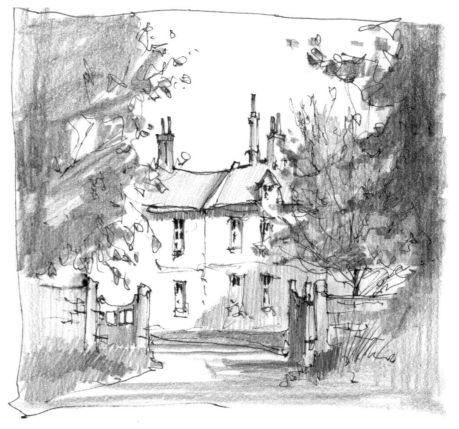

25

Conté and charcoal

Another useful technique for quickly applying tone is to use Conté sticks, charcoal pencils or a combination of both worked over an ink drawing.

Breaking the square Conté stick into shorter lengths helps to access difficult spaces within a drawing. Additional textures can be created by adding notches into the side of the stick with a sharp knife (see below).

Conté stick with notches.

Applying pressure to the stick when working can add variability to the tone created as well as overlaying pigment. In the sample shown below I applied more pressure as I moved it from left to right. I also overlaid more pigment on the right-hand side to add more density of tone.

Conté stick with more pressure applied on the right.

The tree shown below was created by changing pressure as I worked. I created the side of the trunk using the edge of the stick and applying firm pressure. As the stick moved away from the edge, I applied slightly less pressure and the bark textures were formed. The twigs, branches and shadows were drawn using the tip of the stick for an even darker mark. As I drew the branches, I twisted the stick between my index finger and thumb to create a more interesting line.

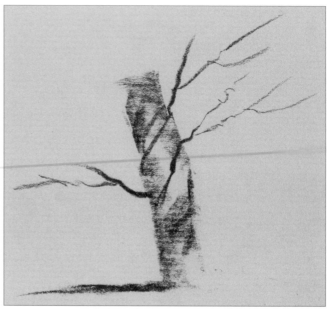

Conté stick tree.

The scene of Robin Hood's Bay in Yorkshire, UK shown opposite (1) was drawn on tinted laid paper using Black Indian ink and a steel nib dip pen. I indicated some key verticals and converging lines with an HB pencil before applying the pen. For the stronger darks, I used a black Conté stick and then worked over some of the lighter areas of shadow with a charcoal pencil (2). Corrections are difficult with charcoal, though a kneadable putty eraser should remove most of the tint. The last stage (3) is to go over with white chalk to add highlights and indicate any sunlit white buildings. The tinted paper shows the chalk marks.

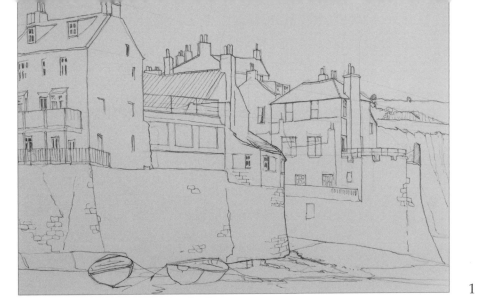

1

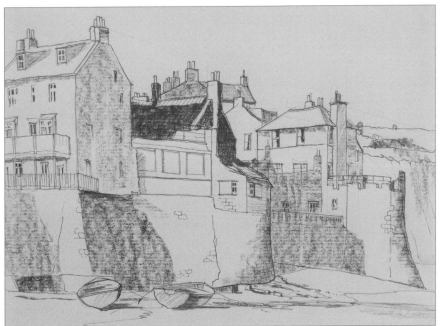

2

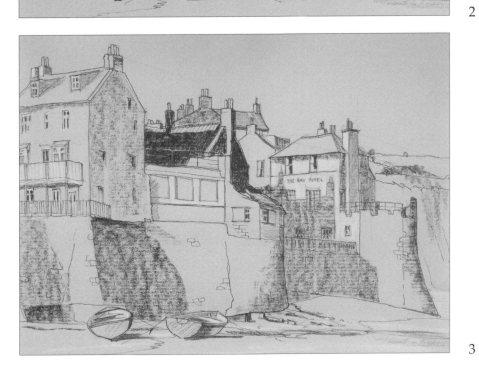

3

27

Zero-point perspective

Scenes that contain structures, roads or railway lines provide us with guides that can be followed back to one or more vanishing points. Vanishing points only exist when parallel lines appear to recede into the landscape. In subjects such as mountain ranges or other natural, non-linear scenes containing amorphous shapes, we are not always able to find any straight edges to act as guidelines to vanishing points. These are zero-point perspective scenes. To create depth and distance in these scenes, there are a number of techniques we can use:

Scale Objects become progressively smaller as they recede.

Detail Things become more indistinct in the distance and shapes become fuzzy and merge into one another.

Placed objects Add something with a known size into the middle distance to give a sense of scale, such as figures, animals, a car or boat.

Mark making Use line thickness and drawing pressure to create depth. Lines become finer and more delicate as they recede into the distance.

Tone or shade The amount of darkness or contrast becomes less as things get further away.

This way of working is sometimes termed aerial perspective or atmospheric perspective, which refers to the effect the atmosphere has on the appearance of an object as it is viewed from a distance. As the distance between an object and a viewer increases, contrast or tonal difference between the subject and its background decreases, and the amount of detail within the object also decreases. The colours and form of the object become less distinct and shift towards a more neutral colour which is usually blue or a subtle violet-grey.

A 3B pencil will provide a good range of tone and line. The tonal scale on page 21 is basically what is used within any pencil drawing. The farthest distance is drawn using the lightest pencil marks.

Intermediate distance is mostly overlaying previous shaded marks using mid-tones, and foregrounds have more strong darks. This gives a three-layered effect of light, mid and dark shades which works well when used in any sketching situation.

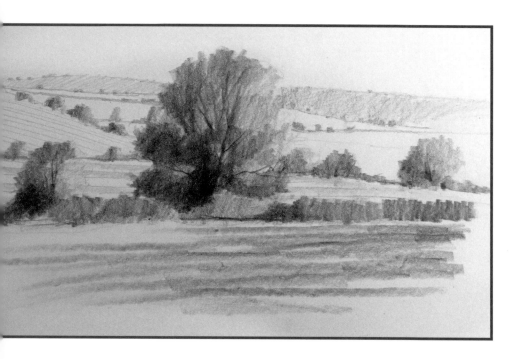

This pencil drawing shows a simple landscape where there are no obvious converging lines that can be traced back to a vanishing point. Instead, stronger tones are used in the foreground and objects become lighter and less distinct as they recede into the distance.

WORKING WITH PEN

Using the right techniques, a good deal of depth can be achieved working with just ink. In this ink drawing 'Ashness Bridge', the distant hills projecting into the lake are shown as fine parallel lines or hatching. Within the most distant hill, the lines are further apart to give a lighter shade. In the middle ground is a bank of trees nestling in the valley. I've used progressively more hatching in this area within the outlines of these forms. In the foreground are Ashness Bridge and rocks. The line work here has become thicker where I have worked several times over the edges. Some detail can be made out within the stonework of the bridge. The tree breaking in from the left has more detail within it. I've also placed some figures in the distance to add a sense of scale.

Most of the techniques described for use with a pencil can also be used with a drawing pen. I tend to use the same size steel nib throughout, changing the pressure to vary line thickness. Alternatively, nibs are available in a wide variety of shapes and thicknesses.

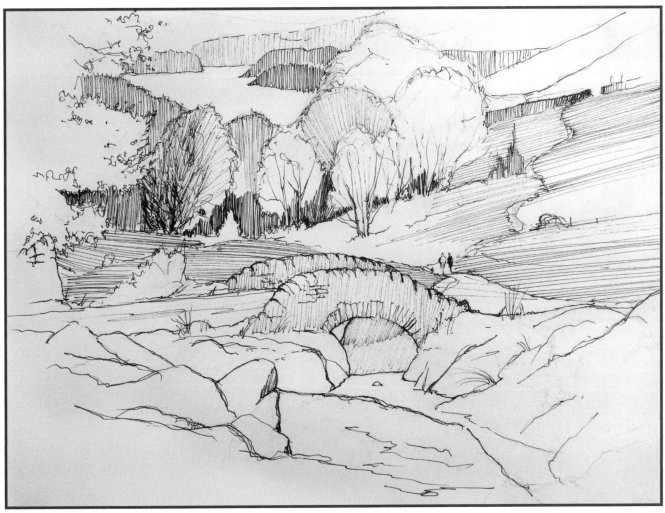

Ashness Bridge

This scene in the UK's Lake District was drawn with pen and hatching techniques.

INTERPRETING PHOTOGRAPHS

The first photograph shows a view across Hoby Meadows in Leicestershire, UK. The river enters the picture on the left and then turns across the scene and exits the picture on the right. With a subject like this, there are very few items which can be used to discover a single vanishing point. The building in the distance faces us directly and the crooked fence on the left recedes into the picture for only a short distance. This is a zero-point perspective scene.

It is seldom that we find a ready-made theme to sketch, and often we have to modify the subject to make a pleasing composition. I started this scene by drawing the mill, ensuring that it was placed off-centre, just to the left. This was to be the focal point. The remainder of the landscape was drawn in outline using a 3B pencil. I started shading the distant trees first with a series of vertical parallel lines similar to those in square 2 of the tonal scale (see page 21). I continued the same style of shading right the way into the foreground tree which I made larger to help balance the composition. The next stage was to move to the middle ground trees surrounding the building and work over the original marks with a series of horizontal strokes. I continued with these strokes all the way into the foreground subjects. Working this way gives a controlled application of shade and more convincing depth. Finally, I worked over the

foreground tree and the dark line created by the river bank. I made the shading on the river lighter as I moved to the right across the page to give more of a sense of recession. I saved the darkest shading for the nearest tree, moving the tip of the pencil in a circular motion to get a darker mark. Finally, I took an erasing shield, chose a narrow slot and lifted out the lights for the two near fence posts. For the next three posts, I used counterchange, making the top of the post dark against the light background and the lower half lighter against a dark background. I decided to add a dark shadow that runs in from the left of the scene and across the base of the sketch.

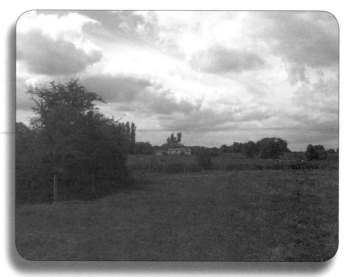

Hoby Meadows, Leicestershire, UK.

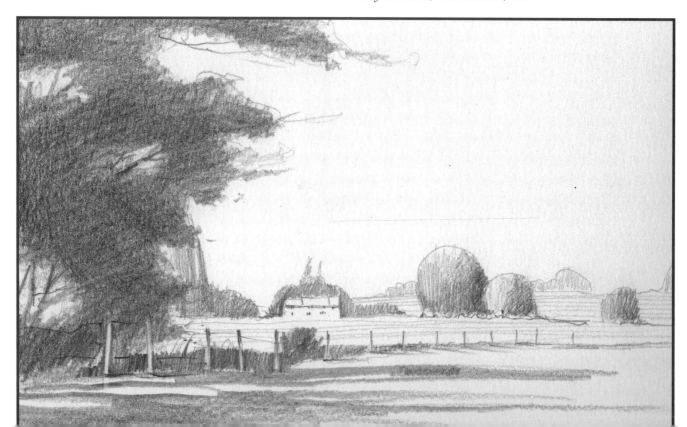

The second subject is an atmospheric or aerial perspective view across the lake towards Grasmere in England's Lake District. It was a day of unsettled weather and the distant hills were disappearing and reappearing from low cloud as I sat and sketched. Again, the only lines in this subject are the horizontal edges of the shoreline which run parallel to the edge of the sketchbook and cannot be used to find a vanishing point. The grey overcast sky was the first part to be added. After applying even tone all over, I lifted out lighter areas of cloud with a putty eraser. I made the hills that are silhouetted against the skyline darker near the top, gradually adding less tone near the ground to give a misty effect. I added the wooded area nearer to me using vertical shading. I pressed quite hard with the pencil in places to get a darker tone. Finally, I indicated some reflections in the lake, making them darker echoes of the darker objects on the land.

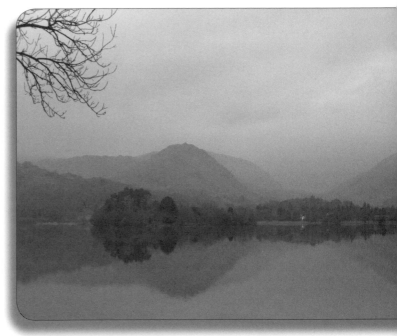

Grasmere, Lake District, UK.

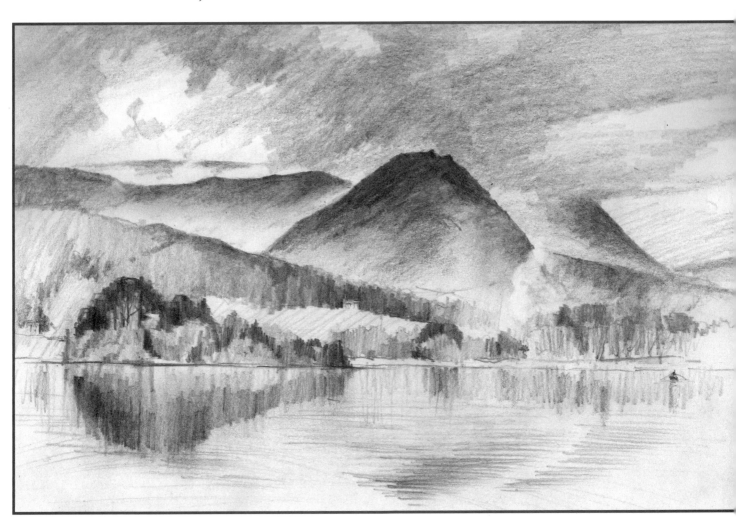

Measurement, proportion and scale

These are probably the three most important things to consider when tackling any sort of drawing. Initially, quite a bit of effort is needed to follow the principles of measurement, proportion and scale, but with frequent use and practice, most things can be done by eye.

There are still elements that can trip us up, especially where an object is foreshortened, appearing to recede into the picture plane. Our prior knowledge when working with this type of subject seems to override what we see and we start drawing what we think we know. Ask anyone to draw a building from memory and often similar elements will appear. Shown bottom left is a typical drawing. The edges are delineated by strong lines, with little use of shade. The whole subject is enclosed in a line of similar thickness. The windows are added as squares with crosses whose edges are out of alignment with the edges in the rest of the building. Interestingly, our viewpoint, which would normally be from street level, is much higher, causing the gutter of the building to appear to go uphill.

Here (below, right) I have drawn the same building in proportion. I measured the sunlit end of the building against the shaded front and found them to be almost identical in length, even though an optical illusion makes the front of the building look longer. Generally when working, I use my fingers as a pair of calipers and compare the relative size of objects within a scene (see right). As long as the proportions are approximately right, the drawing will look acceptable. The case is slightly different for portraiture or figurative work, where slight errors of measurement can stand out. Sometimes, drawing errors can be spotted by looking at the subject in a mirror or turning your work upside-down.

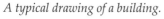

A typical drawing of a building.

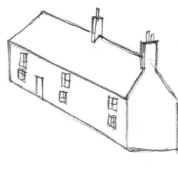

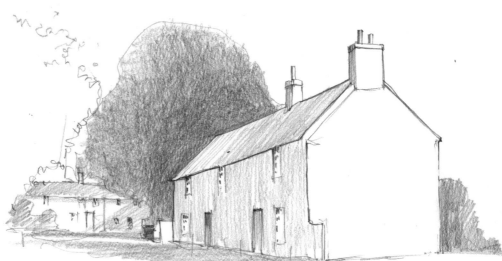

The same building in proportion.

Some measurement of line lengths is required when working on a sketch. I use a pencil and my thumb to record the position of a mark which I can then use as a comparison against other edges (see right). For example, the height of the near corner of the building can easily be compared with the height of the far corner.

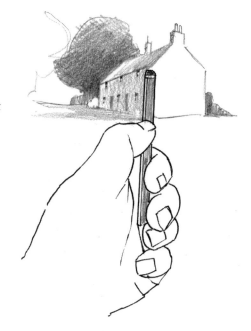

ANGLES

Measuring angles is probably one of the most important things to do when viewing a landscape subject. I use a pencil and slide it up and down the guttering on a building and observe which way the tip of the pencil points. When viewing two-storey buildings at street level, this edge will always appear to slope downhill (see top right).

A useful tool to own is a homemade angle finder. Mine is cut from picture framer's mount card and the two parts measure 2 × 20cm (¾ × 8in). Join one end with a brass split pin paper fastener. The tonal scale can be glued or redrawn onto one of the sides and used as a means of judging tones within a subject. The drawing bottom right shows it being used to discover the vanishing point of a building by lining up the two edges with the vertical side and gutter of a building. As this angle is often held fixed, the shape can easily be transferred to a drawing or sketch. The divisions of the tonal scale can also be used to record the sizes of measured objects within a scene.

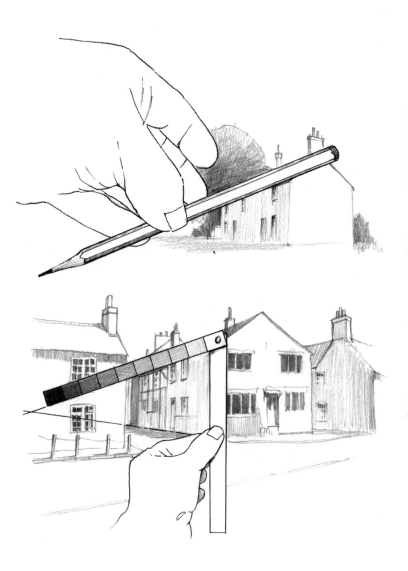

Single-point perspective

Realistic drawing relies heavily on the principle that parallel lines receding into a picture appear to converge on the horizon at a single spot known as the vanishing point.

Single-point perspective is one of the simplest ways of representing reality and was the main system practised by artists from the Renaissance up to the early 20th century. Paintings and drawings based on the single-point system have an impact of their own. Placing objects in key positions near the vanishing point ensures that the eye is drawn to them by the way converging lines within the scene are arranged. For instance in his fresco, *The School of Athens*, Raphael attracted the viewer's gaze to a single point in what is quite a complex grouping of figures by making all the receding lines converge at the single vanishing point, where Plato holds a book in his left hand (see page 10).

Probably one of the most famous subjects containing a single vanishing point is Leonardo da Vinci's *The Last Supper*, situated in the convent of Santa Maria delle Grazie, Milan. The painting depicts a rectangular room which terminates with three windows placed on an end wall. Through the windows, a distant landscape scene is visible, with a misty grey horizon. Leonardo was already familiar with the technique of using aerial perspective techniques to create depth. For the remainder of the painting he employed single-point linear perspective. All the lines within the scene converge to a vanishing point in Christ's head, emphasising the central importance of the main figure.

Although now somewhat deteriorated, in its day the painting was so effective that the work appeared to be an extension of the refectory building on the wall of which it was painted.

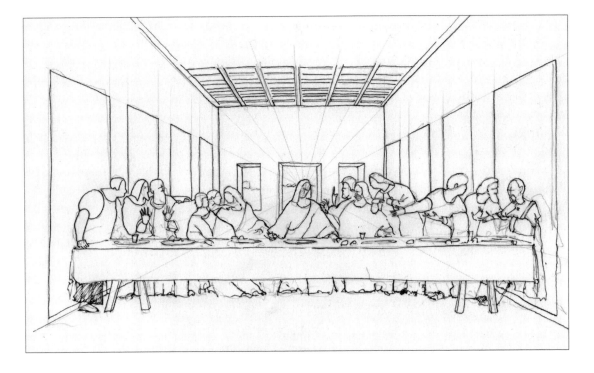

Single-point perspective becomes more apparent when looking down a railway track (see below). Although the sleepers are all the same width, as they go into the distance, they appear smaller to the eye and the track converges to a single vanishing point. The station building and picket fence located on the left of the track obey the same rules.

The theory of perspective is based on the action of light rays travelling in straight lines from the object to our eye. From all these rays, our brain constructs a likeness of the object. Between our eye and the object is an imaginary place where what was in three dimensions comes down to two. This area can be visualised as a large, flat sheet of glass and is known as the picture plane (see right). We often interpret what is going on in the picture plane when we draw on a sheet of paper.

We can all create our own picture plane by drawing an outside view on a glass window with whiteboard markers. It soon becomes apparent when doing this how important the head position is. A slight movement, or viewing the scene through the left instead of right eye will make the scene shift away from the marks already made. One of the devices developed by Albrect Dürer shows a portable picture plane in action (see page 11). Note the column for keeping the eye in the same position.

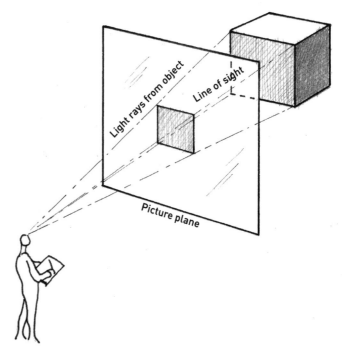

Diagram of the picture plane.

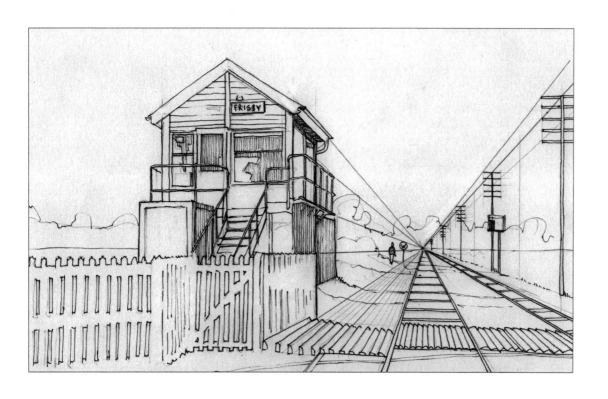

If we place ourselves where the viewer is looking at the end and centre of the box (below), all the near edges of the box are parallel to the edges of the picture plane. The eyeline is also parallel to the top and bottom edge of the picture plane. If the box were semi-transparent, we would be able to see the far side, which would appear smaller, as it is further from our eye. The edges all converge to a single vanishing point in the centre of the box.

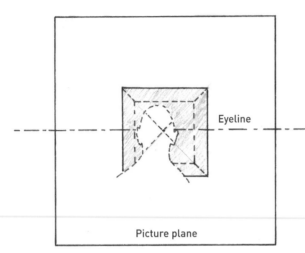

The viewpoint from the end and centre of the box.

If the observer now stands on a stool (below), the eyeline and vanishing point follow the viewer's eye and elevate upwards, allowing the person to see the top surface of the box. The far edge of the box is still further away from the observer's eye and appears smaller. Lines taken along the outside edge still converge at a single vanishing point.

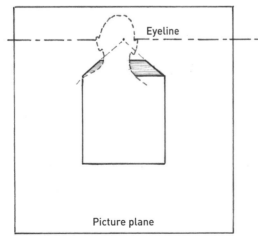

Viewer standing on a stool.

If the observer sits down, the eyeline and vanishing point drop along with the viewer's eye and the bottom of the box becomes visible (below).

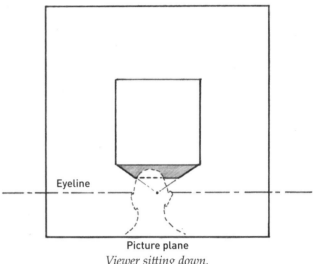

Viewer sitting down.

By moving to one side (below), the vanishing point will slide along the eyeline so that two sides becomes visible. So effectively, the appearance and arrangement of the object we view is greatly influenced by our head position. We tend to see the world from a standing position and I try to paint from the same view. By sitting down to work on a subject, the angles and positions of objects change subtly in a scene. If standing for long periods is a problem, then completing the drawing from the standing position before sitting down to complete the painting is always a good start to a piece of work.

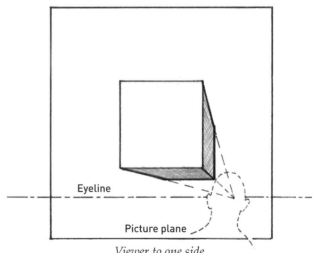

Viewer to one side.

RADIAL DRAWING

A subject like Sansome Street in Philadlelphia, USA, might seem on the face of it a complex scene (see right). Establishing a few key features helps to make the drawing process easier.

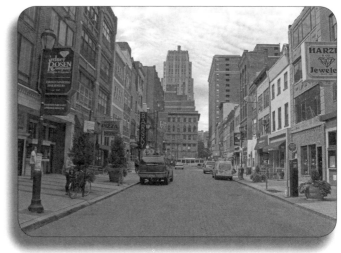

Sansome Street, Philadelphia, USA.

1 Firstly, the vanishing point. By taking a ruler and drawing a series of pencil lines along the window ledges and the sidewalk on the photograph, I find a point of convergence. The point is approximately the third window on the bus crossing at the end of the street (right).

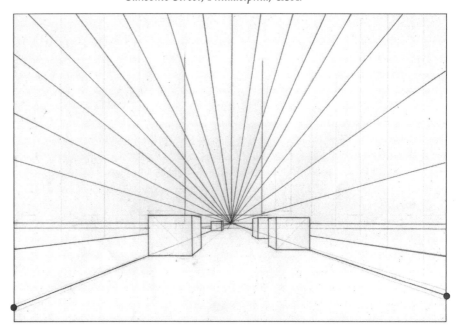

2 Next is the eyeline. This is the approximate height of the photographer's head from the ground, and this horizontal line will run through the vanishing point. To draw the roadway, I look for where the edge of the sidewalk exits the side of the frame and mark the position with a dot (right).

3 Next I add boxes to represent the parked vehicles. The bottom corner of the box touches the sidewalk; the top is slightly higher than the eyeline. A rough measurement shows that the end of each vehicle is a square shape. The sides are roughly one-third the width of the end and these edges go to the same vanishing point. I then draw a series of lines radiating out from the vanishing point, placing them at regular intervals, judging by eye without measuring. These will act as guidelines for the drawing.

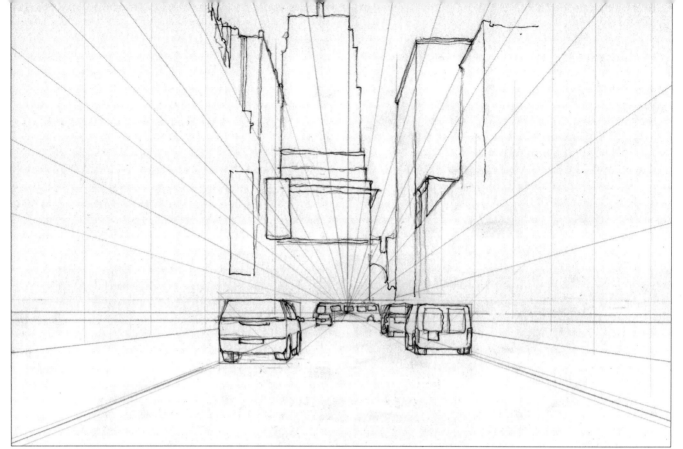

4 I add a few verticals, especially near the edge of the frame, to compensate for any curvature that often occurs with a camera lens. I draw in the vehicles and bus in fibre-tipped drawing pen, within the boxes, and these help as a reference for other key lines. I then work outwards in all directions from the vanishing point. I call this technique 'radial drawing'. It helps to keep everything in proportion and scale, as my references with other drawn objects are always close by.

5 I work lightly outwards with the pen until I reach the edges of the frame, using the radiating lines as a guide. I place the figures on the sidewalk by just adding a head and shoulders near to the established eyeline.

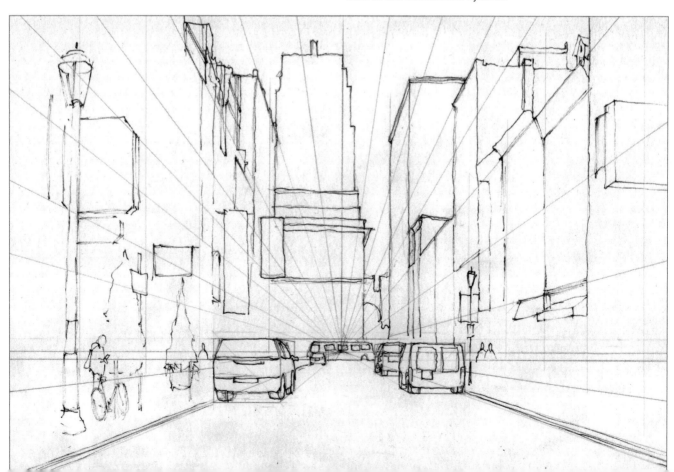

6 The lamp post near the edge of the frame could easily have been drawn curving inwards if I hadn't added any vertical guides near the side of the paper. For the final stage, when I'm happy with the drawing I add window detail. I've made quite a few drawing mistakes along the way (can you spot the missing building?) and so I adapt the window positions to compensate for this. I finish off the figures and make some of the lines bolder by overworking them with the pen.

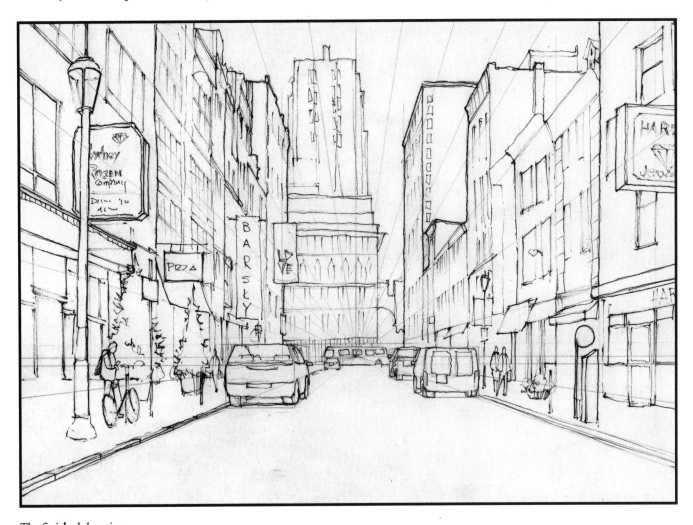

The finished drawing.

Two-point perspective

A BOX WITH TWO VANISHING POINTS

Most of the subjects we view will have at least two vanishing points. When viewing a cube that is rotated at an angle to the picture plane, we see two sides receding into the distance (see right). We are not looking down on it; our eyeline runs through the centre of the cube. The top and bottom edges appear to slope away into the distance whilst the vertical sides remain parallel to the edge of the picture plane (see below).

Although the cube is equal in size on all sides, perspective makes the depth appear shorter compared to the height. This is called foreshortening.

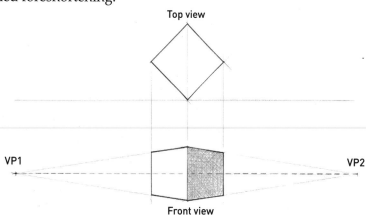

If we raise our head to a higher position, with the eyeline still lined up with the nearest corner but raised above it, the top and bottom edges start to slope upwards and the top of the cube becomes visible. However, because the eye position is still in line with the near edge, the depth of the cube remains the same (see below).

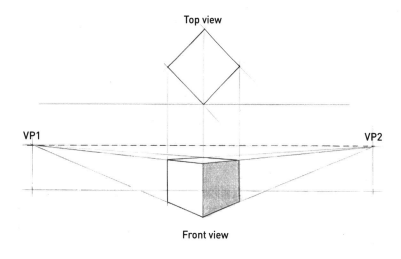

CONSTRUCTING A HOUSE

When constructing a building, a good starting point is to draw the vertical edge of the corner nearest to the eye. Then draw a line horizontally through the vertical line – this establishes the eyeline or horizon. Here I have decided the viewer is standing in the street looking at the house. I choose a point one-third up from the base of the building.

I can now introduce a vanishing point. Drawn objects become more believable if the two vanishing points are placed an uneven distance apart with at least one placed outside the edge of the drawing paper. It's also useful if one vanishing point is put on the paper near to the side that contains the most detail. For this subject I add a vanishing point on the right-hand edge of the paper and then connect with two fine lines to the top and bottom of the vertical edge (see below).

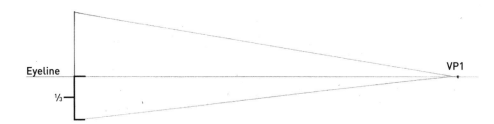

Next we need to decide on the depth of the building. The end furthest from our eyes could be placed anywhere along the eyeline to make a detached house or a long terrace of buildings. I decide to make the length the same as the height and add the next vertical. This building will have five windows with a door in the centre. The middle is found by dividing the space with two diagonals running from corner to corner on the front wall. Where these lines intersect is the centre, marked with a vertical line. I repeat this to find the centre of the two halves just created, dividing the front wall into quarters by drawing two more sets of crossing diagonals (see below).

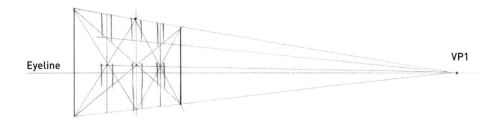

Windows are added to these positions by drawing two parallel lines down from the guttering. These lines can then be transferred to the lower level. Remember that these lines must be closer together as they recede into the picture. The top of the door frame and windows are just higher than the eyeline. If they were lower, we wouldn't fit through the door! I add the upper windowsills in a position that looks in proportion to the rest of the house.

To complete the construction, I now add the second vanishing point. This needs to be placed some distance away to make the object look convincing. To determine the position of the second vanishing point without a real subject as reference, I use a rule of thumb method of placing it four to five building widths away from the object (see below).

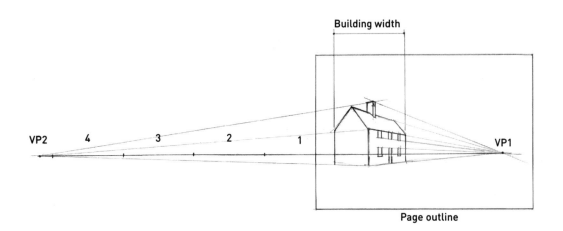

I can now take two lines from the near edge to the second vanishing point. I make the width of the end wall the same as the height.

Next I divide the end wall by drawing two diagonal lines from corner to corner. A vertical line is added through the diagonal centre. I decide to add a 45 degree slope to the roof using a 45 degree drafting triangle. Where this line intersects the end vertical is the roof line. The angle at the rear of the building is drawn by connecting the two points. I add the slope at the far end of the building with the same angle. The chimney is in the middle of the roof. I extend the centre line using the same 45 degree angle as for the front roof edge. I add a chimney, judging the widths by eye to make it in keeping with the rest of the building. The top edges of the chimney are projected back to the two vanishing points (see below).

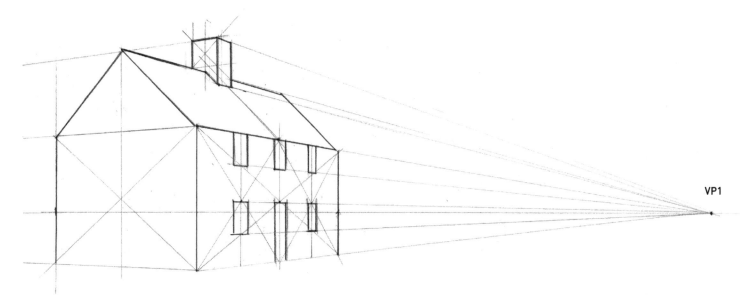

A house from another viewpoint

This picture shows the building with the same dimensions but with
a raised viewpoint, as if the viewer had entered a building and was
peering down from an upper storey. The two vanishing points have
risen equally but everything else is in the same position. Note how the
guttering now slopes upwards, as does the floor. The eyeline is now
just a little higher than the roofline of the building which will tend to
make this edge look horizontal even if it is sloping upwards slightly.

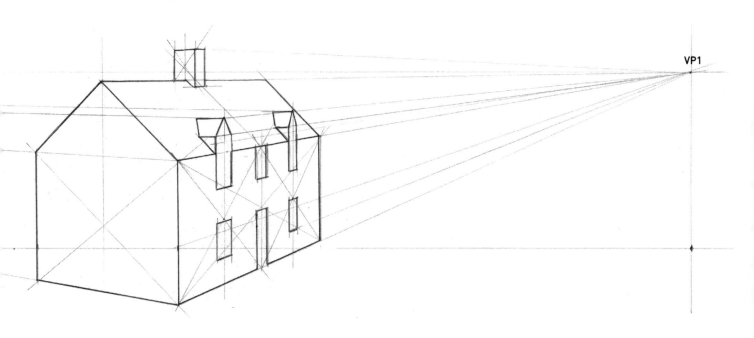

In this situation, the viewed angles of an object become misleading
and knowledge of perspective will allow you to make the correct
decision based on the position of your eyeline. I also added a couple of
dormer windows on the upper floor. These have to be projected back
to both vanishing points and the 45 degree angle has been used where
they merge into the sloping roof.

MORE COMPLEX BUILDINGS

This subject is a more complicated arrangement of buildings. However, they all converge at two vanishing points on the left and right. Having the photograph allows me to scale the position of these two points, both of which are outside the paper area. I like to use decorator's lining paper as a cheap material to draw on when using points that are off the paper. Taking the Shake Shack building as my principal subject and measuring the width, I can position a vanishing point five building widths from the closest corner (see below). The other point is just outside the right-hand edge of the paper. To get it onto the paper, I would have to have estimated the size of the buildings a little smaller. Looking at other objects within the scene to use as a measuring device, such as the traffic lights, I can work out the height of the nearest building and mark the top. I then take converging lines back to both vanishing points. I draw a series of lines fanning out from each vanishing point with little regard to the subject being drawn. A freehand drawing can then be completed without using a straight edge to build up the subject. I have left the drawing partially finished so that all the construction lines are visible.

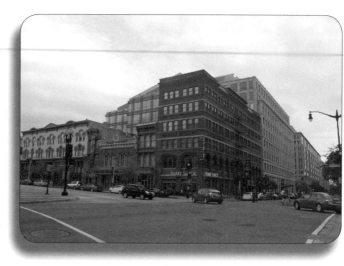

Shake Shack, 9th Street SW, Washington DC, USA.

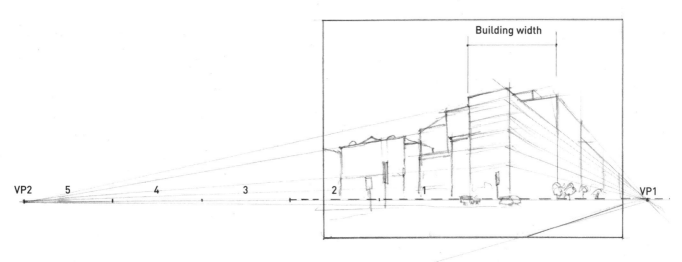

The numerous windows on the right side of the building are drawn receding into the distance, getting smaller and lighter in line. Some of the furthest windows are just a single vertical line. The lines fanning out from the right-hand vanishing point help me to position the sills and lintels. I don't bother to count the windows, just place them evenly in the space so they look convincing. The vehicles on the road are drawn inside a box. This helps with the one on the right, which is slightly turning. The trees going off into the distance on the right have grown at different speeds and so the tops of the canopies do not all fit along a line. This helps to give a more natural look to the scene. I used the right-hand vanishing point to project a line over the traffic light near the building to get the height of the second set in the foreground. I could then add street furniture, scaling against this new set of lights.

The finished drawing.

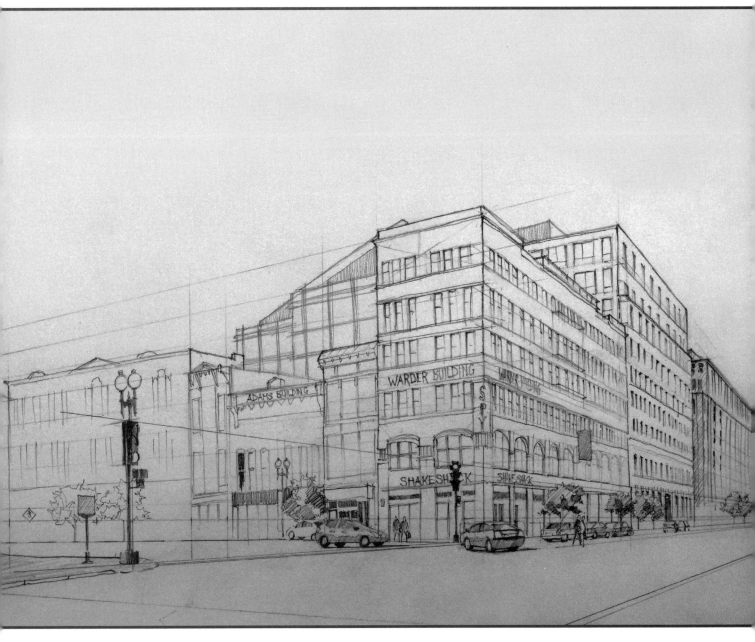

45

DIVIDING DEPTH

Division of depth is something that crops up quite often in perspective drawing. Things can simply be divided in half by drawing diagonals and then marking where the two lines intersect. It becomes more of a problem when something such as a line of fence posts or telegraph poles recedes into the distance.

Starting with a vertical line representing a pole or post, draw the eyeline through the centre of the post and then add a single vanishing point to the right and allow two lines to converge to this point (see below).

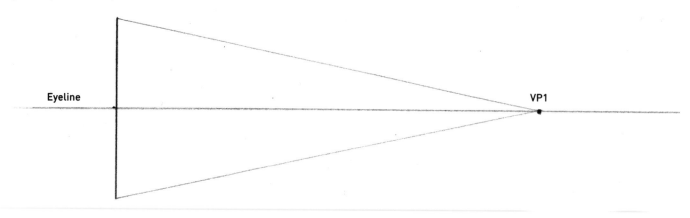

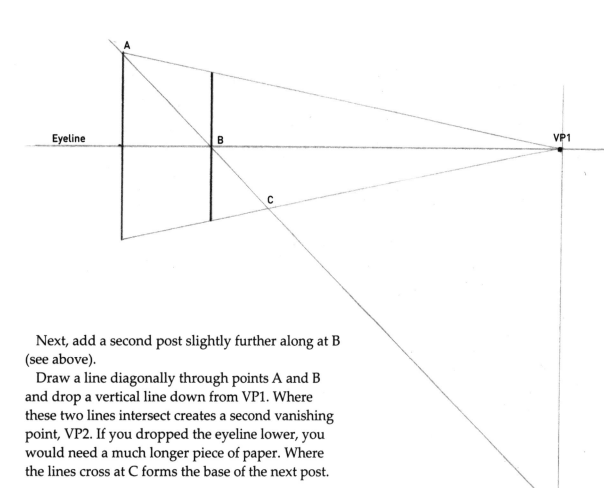

Next, add a second post slightly further along at B (see above).

Draw a line diagonally through points A and B and drop a vertical line down from VP1. Where these two lines intersect creates a second vanishing point, VP2. If you dropped the eyeline lower, you would need a much longer piece of paper. Where the lines cross at C forms the base of the next post.

At the top of the second post, B, draw a line to VP2 to create the base of post D (see below). Continue with this method until all the posts along the line have been marked out.

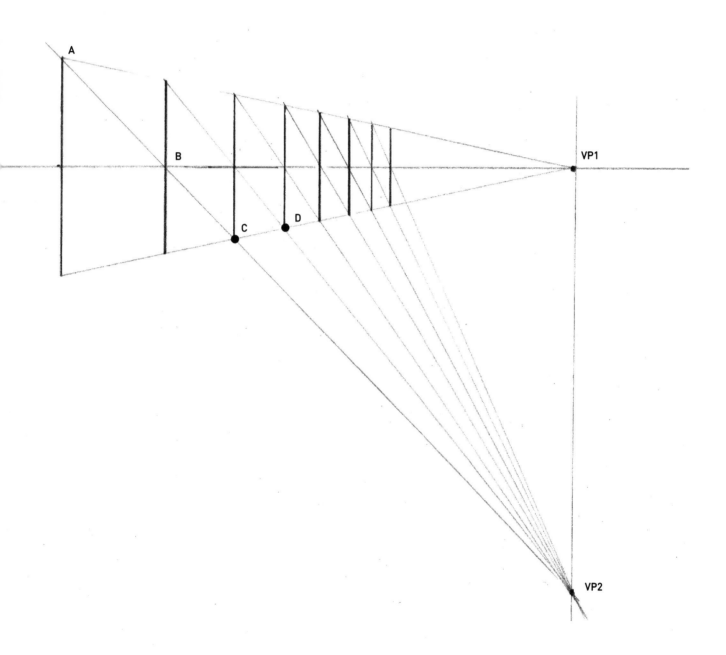

HAMPTON COURT

The gardens of Hampton Court Palace in London have avenues of finely manicured yew trees which have all been carefully trimmed in a similar manner. This uniformity makes drawing using two vanishing points easier than if the trees had been allowed to grow to different heights and shapes over time.

I want to view the trees from a standing position, so I add a figure as reference, then take an eyeline through that person's head. I estimate the nearest tree to be approximately five figures high, and it is trimmed so you can just walk underneath. With the height marked, I draw two vanishing points but keep them an unequal distance from the centre line of the nearest tree (see below).

I project lines from the near tree to converge at the two vanishing points. I also add a stronger line to denote the curb (see below).

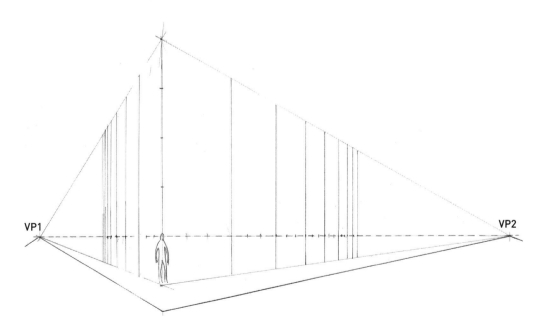

To divide up the area, spacing out the tree trunks, I could use the method described previously. However, I like to use a less complicated rule of thumb method. I mark off the trees either side of the main trunk. The spacing I have chosen reduces the space between each new trunk by a third. As I add a new tree, I measure the distance and then reduce the distance of the next one by a third until I have reached the end of the row (see below). I use the same rule for the trees on the left. This method of working looks acceptable to the eye and can be used on fence or telegraph poles receding into a landscape.

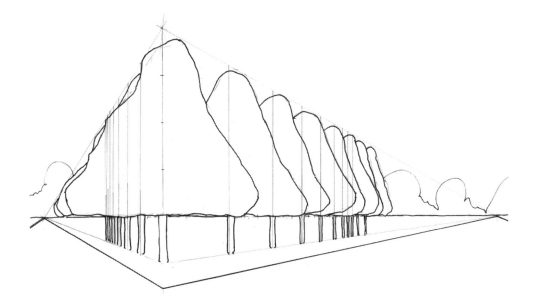

Once I have this basic structure, I can draw in the outline of the trees as they recede into the distance with fibre-tipped drawing pen. I can then finish the subject by adding shade using a 3B pencil (see below).

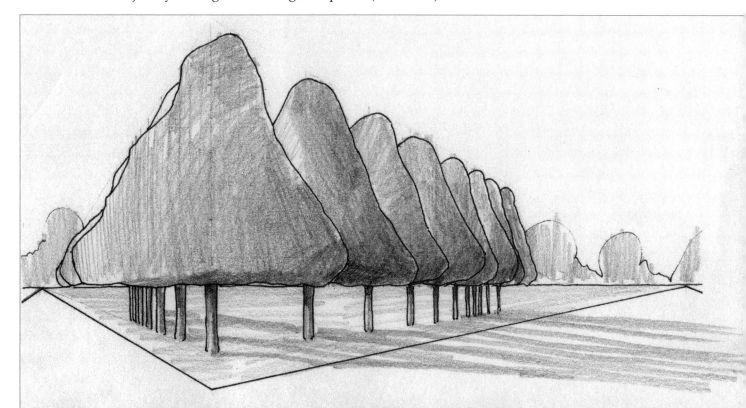

Multiple-point perspective

Although we're not always aware of it, three-point perspective plays an important role in our drawing, especially when including subjects such as tall buildings or towers. When we stand at the foot of a high-rise block and look upwards, the sides of the building no longer look straight but appear to taper inwards. The same applies if we stand at the top of a tall building and look down. What we see is a third perspective point coming into play. This phenomenon is also present in smaller objects, though we are not as aware of it.

The drawing below left shows a view of a cube similar to the one on page 35 showing two-point perspective. The eyeline is higher than the cube but remains lined up with the near corner. I have added a third, lower vanishing point which helps to give a bird's eye view. Here it is visible on the paper, but normally it is placed further away so the sloping sides become more subtle. The change when using three or more perspective points is that no edge of the cube is parallel to the picture plane.

The drawing below right is another cube where the eyeline runs through the centre of the nearest vertical edge. We can now add a fourth vanishing point so that the edges taper top and bottom. Again, this is happening when we view an object, but often our eyes are so near the base of the subject when we look that we don't perceive this fourth vanishing point happening.

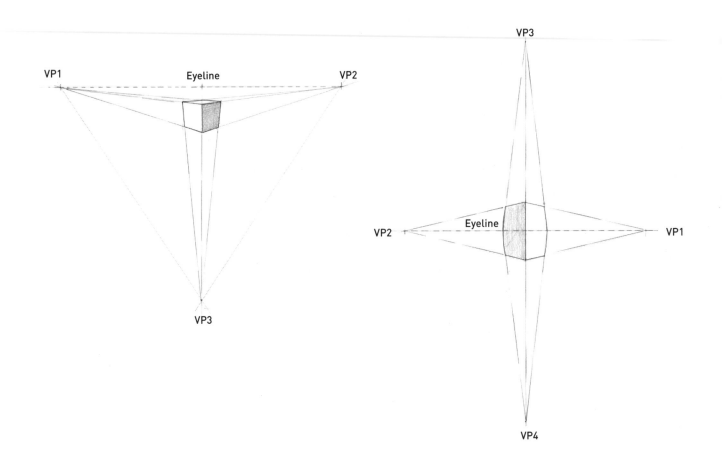

When we analyse photographs, we can often detect these vanishing points. The photograph (right) of Thornham village in Norfolk, UK, has three vanishing points. VP1 is way off into the distance to the left of the buildings. VP2 is closer by, just to the right somewhere near the top of the wall. A third vanishing point VP3 can be seen as the tall tower at the end of the street has converging lines that disappear high up into the sky.

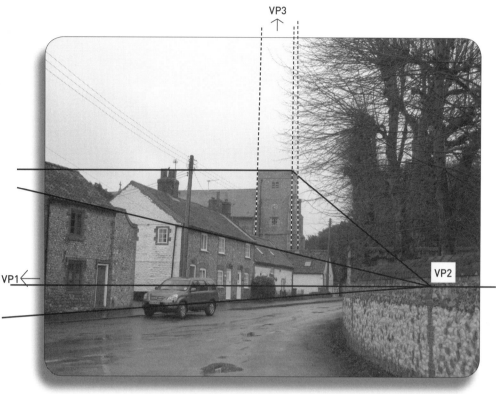

The Customs House in King's Lynn, Norfolk, shown right, has numerous lines that all converge at VP1, as do the edge of the keyside and the lamp standards on the right. The lamps appear to curve inwards. This is caused by distortion of the camera lens and would need correcting. A second vanishing point VP2 goes off to the left and converges quite a way away. A third vanishing point VP3 is created by the Customs House building and goes up into the sky. Note that the line of the corner nearest our eye is usually straight. A fourth vanishing point, VP4, can be seen in the reflection and converges some distance downwards.

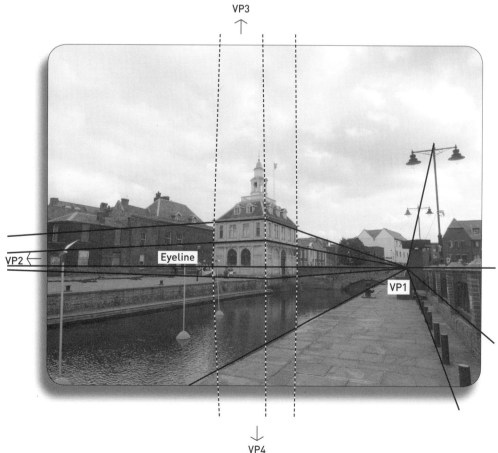

51

THE HOUSE IN THE CLOUDS

This drawing shows a converted water tower in Thorpeness, Suffolk, UK, known as the House in the Clouds. I have constructed this building using three-point perspective. The eyeline is placed low, about halfway up the doorway and a vanishing point is placed at the side of the sheet. I add a second vanishing point off to the right and a third high up, using a much larger piece of paper. Placing this vanishing point too close to the object will make it appear to taper unrealistically and a little trial and error is required to get the correct placing. It may seem odd, but tall buildings still have to obey the rule that the vanishing points are placed on a horizion or eyeline which reflects our head position. Notice also that the building is presented at an uneven angle, so instead of using the nearest corner, I have added a straight line which runs vertically through the apex of the roof. I add all the construction lines that will help me draw the building.

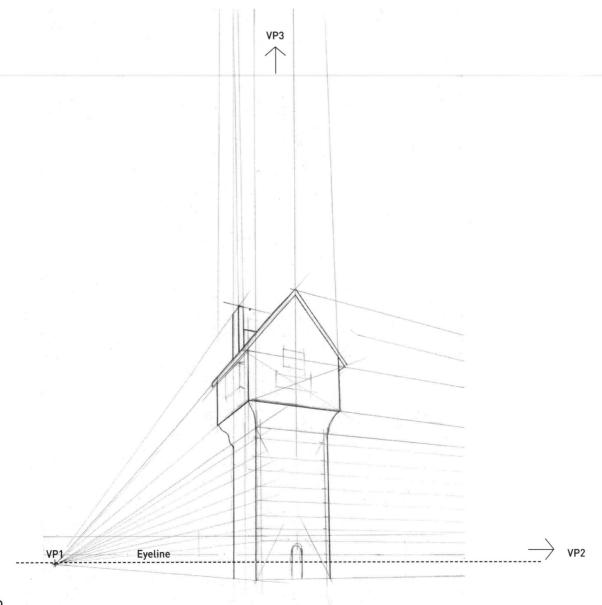

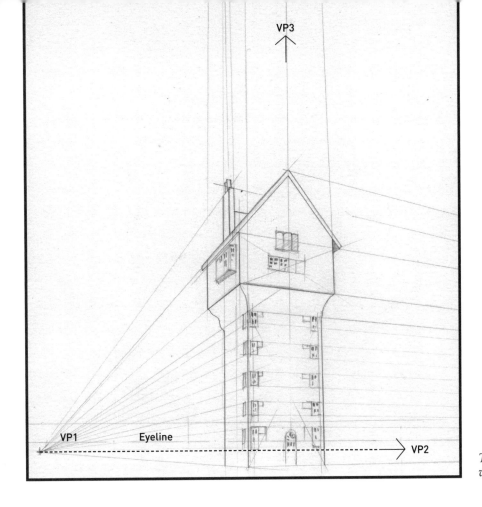

This drawing shows the finished building with the construction lines left in.

Simplifying perspective

Three- and four-point perspective can seem complicated, but unless we specialise in drawing and painting tall buildings, the third vanishing point can largely be ignored and we can assume that on a normal two-storey building, the verticals are upright. I have drawn the House in the Clouds using just two-point perspective (see below) and although it looks OK, because we are used to looking at tall buildings, the top of the tower seems to taper outwards a little like a vase. Without the tapering lines produced by the third vanishing point, the building doesn't feel so tall and the drawing lacks the dynamism that the three-point construction provides.

Varying perspective

When out sketching and drawing, it's not always convenient to use straight edges to create vanishing points and converging lines, so it is often necessary to resort to a rule of thumb way of using our perspective knowledge and estimating where lines go to converge. An issue we all have of which we are not always conscious is the distortion of objects outside our area of vision, which doesn't include our peripheral vision. Known as the foveal area, this is the only part of the eye that allows us clear and distinct vision. Most people have approximately sixty degrees of vision, extending as an imaginary cone from their eyes. Outside this area, things start to become distorted. For example, if you go to the cinema and want to see the entire screen comfortably, you should not sit on the front row, but further back.

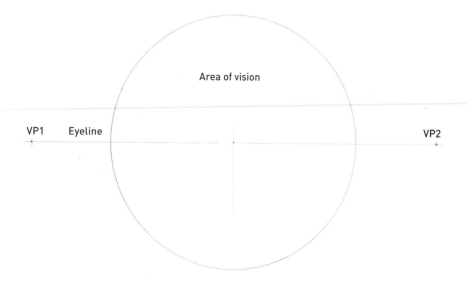

This diagram shows two vanishing points, a horizon and the area covered by our cone of vision, which occupies approximately 60% of the horizon line. Things drawn inside this circle will look acceptable, but things drawn outside will start to look distorted.

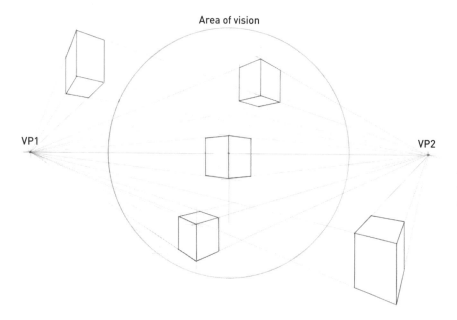

This diagram shows a series of blocks, with two added outside the circle of vision. Note how the angles of the corners start to look distorted.

The distance of the viewer from the subject also affects where the circle of vision lies. This position is known as the station point. The distance you stand from the subject makes a great deal of difference when it comes to the edges of the drawing. A rule of thumb is to position yourself at a distance of approximately four to five times the height of the object being viewed. So if you estimate the subject to be 10m (33ft) high, then try to view it from 40–50m (131-164ft) away.

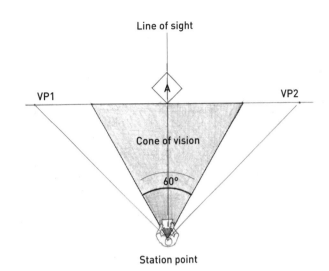

Line of sight

VP1

A

VP2

Cone of vision

60°

Station point

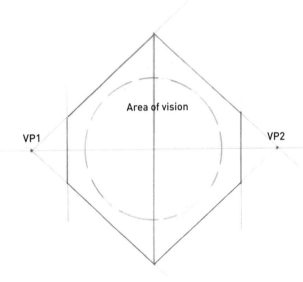

Area of vision

VP1

VP2

If we approach box A very closely, the vanishing points move inwards and our cone of vision becomes smaller so we would see something like the diagrams shown right and below.

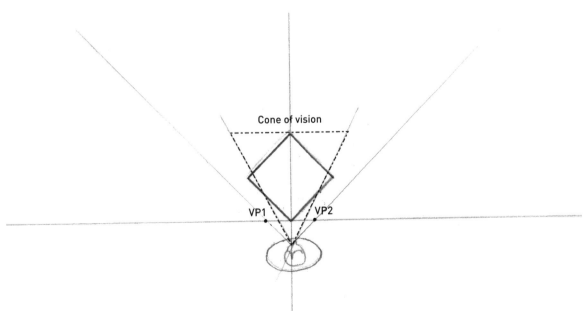

Cone of vision

VP1

VP2

As I sketch and draw, I am aware of a number of these perspective elements, so even though I don't add any vanishing points, I have a rough idea of where they go. Take the sketch of Ciutadella below. I added the vanishing points later after I finished the drawing, and they converge at a single vanishing point VP1 in the lower third of the sketch. Unfortunately, I was a little less accurate with the angle of the pavement on the right. I allowed for a second higher vanishing point using the tower at the end of the road and made the walls of this building taper inwards slightly. Distortion tends to occur near the edge of the drawing where the line of buildings is. The guttering slopes downwards at a very steep angle towards VP1. In some circumstances, these edges can be nearly vertical.

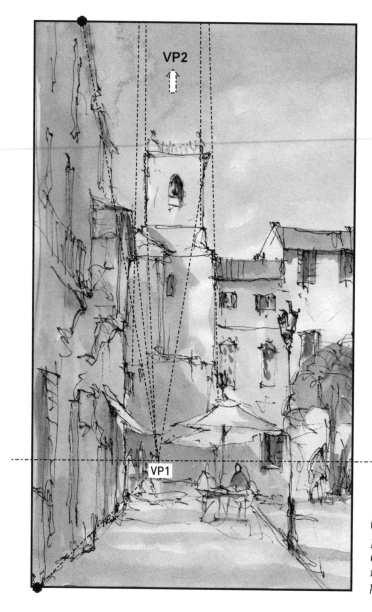

Ciutadella
I had already completed this drawing of Ciutadella in Menorca, Spain, and drew in the perspective lines and two vanishing points afterwards.

It is useful when drawing to observe not only where these lines vanish to, but also where they exit the frame of the paper. A useful device to help with this is a card viewfinder that has a small rectangle the same shape as your paper cut into it. This can be used to frame the object and highlight for you where the exit points of all the main perspective lines will be.

The pencil sketch below is of an imaginary place. I drew it as a precursor to a pastel painting. After placing the farm building on the focal point, I emphasised this area by adding perspective lines converging in the field in front to attract the eye to the building. I also exaggerated the slope of the farmhouse walls to give it more of a quirky feel.

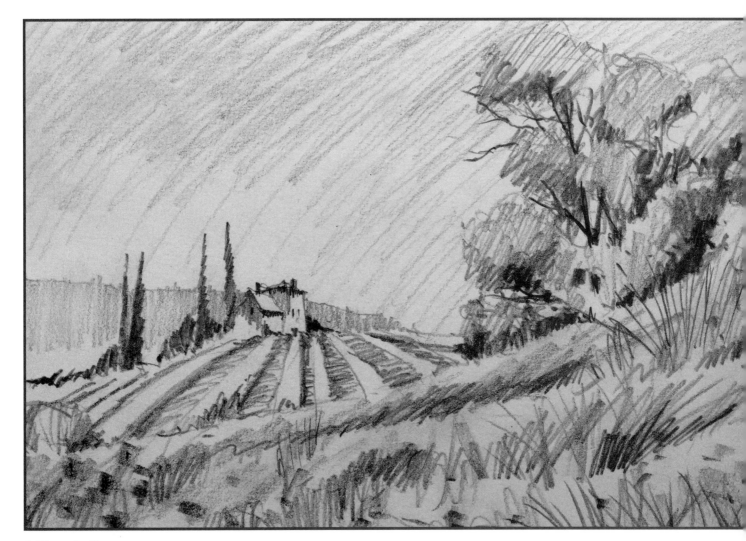

A Place in France

Here, the perspective lines in the field help to create a dynamic scene, and aid composition by leading the eye to the focal point of the building.

When sketches are carried out on the spot, my perspective lines do not always converge at a vanishing point. Instead, I use a vanishing area: a wider space in which the lines converge. The sketch of Frisby on the Wreake in Leicestershire, UK, still looks convincing, and allowing the lines to converge to an area rather than a single spot gives the artist a little more flexibility in compensating for any distortion that may occur at the edges due to the position of the station point.

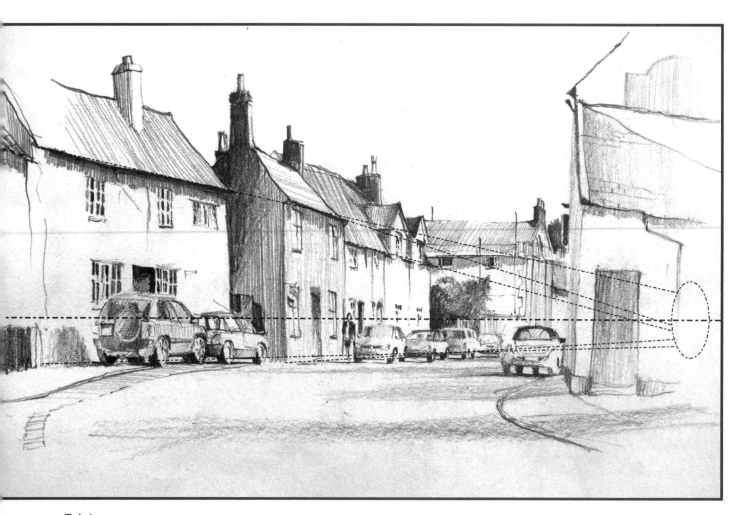

Frisby

When it came to analysing this scene, sketched on the spot, I saw that the perspective lines don't converge at a single point, but in the area marked with an ellipse on the right. Nevertheless, the perspective still looks convincing.

This sketch of a Lancaster bomber was done in an air museum. Aircraft, like boats, are tricky subjects, as they are comprised mostly of curved surfaces. However, they still obey the rules of perspective and this must be taken into account when comparing the size of one shape against another. A technique I have used in this sketch is to vignette or fade out the edge where the wing comes outwards towards me and past my head. Vignetting is a useful technique where edges are faded of left out, with the central area being detailed to compensate for any drawing problems that may occur at the edge of the sketch.

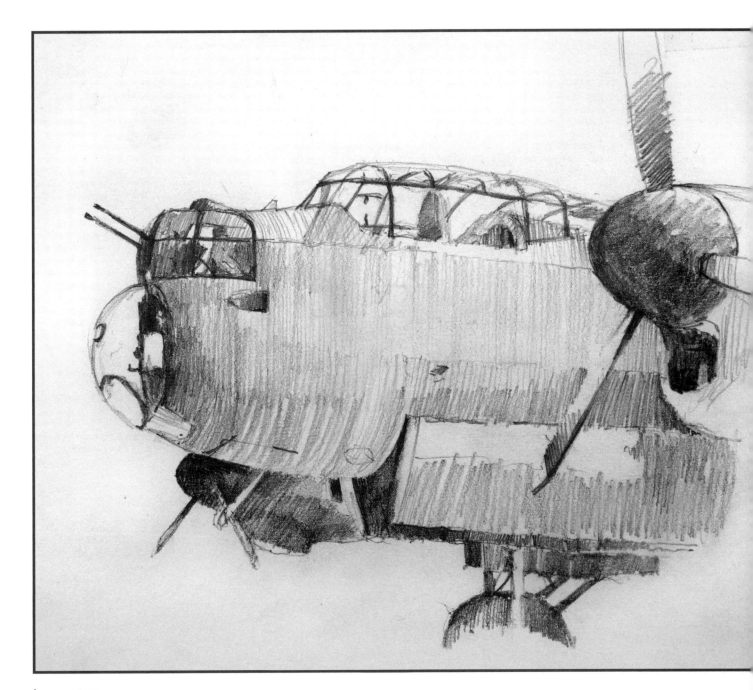

Lancaster

Note how the elements of this sketch which came towards or even past me as I sketched are left faded out and unfinished, a technique called vignetting.

People

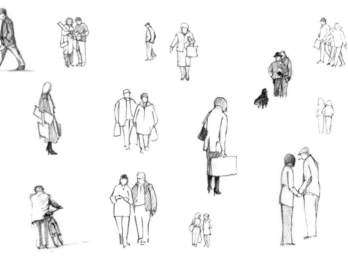

Looking outwards from a roadside café or finding a seat in a busy shopping mall provides good subject matter to sketch and helps to give an idea of the attitudes and proportions of the human figure.

Generally, when working with ink, the figures go into the drawing at the same stage as the background. Adding figures later can cause problems with removing drawn ink lines. Pencil is a little easier as people can be placed using a nearby object as reference and by removing unwanted lines with an eraser and erasing shield.

If you stand on a level surface and observe a crowd, all the heads appear to be about the same height as they recede into the distance (children excepting). Stand to look at people walking on the beach and their heads will be touching or near the horizon line made by the sea.

When drawing groups of figures, all you really need to know is where your eye level is (see below). If you're standing up, it will be approximately in line with everyone else's head. You can draw figures simply in a crowd by drawing all the heads along the eyeline, making the heads different sizes, then drawing the bodies in proportion. The head is normally drawn as an oval and should fit into the body of an adult seven and a half times, or for a small child, about four and a half times.

If we need to place people in scale to other objects receding into the background, then it's easier to add a vanishing point. In the diagram (below) I've added two vanishing points for ease of working. Take a horizontal line across and add a person anywhere along this line, making sure the head finishes near the eyeline.

If we observe people on a flat surface, from a sitting position, our eyeline drops to just below everyone's waist (see bottom of page). Even in this situation, we could still draw the crowd without any vanishing points, as the eyeline passes through each figure at the same point. It is easier if we add lines at the top and bottom, converging back to VP1. I've added another person in the distance by drawing two horizontal lines across the page from the furthest figure. I often draw figures by reference to a wooden articulated mannequin. This helps to get the posture correct and the arms and hands in the right place. I can then flesh out the body and add clothing.

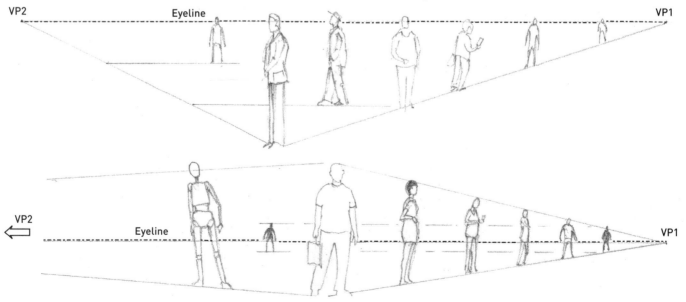

A MORE DEVELOPED DRAWING

This drawing (right, top) shows an empty station platform with a single vanishing point in the distance. I can use this to set the height of the horizontal eyeline. I then add a principal figure to the left, midway down in front of a doorway. I draw a line back to the vanishing point through his feet. Taking horizontal lines from here, I can plot where the other figures will stand on the platform. Platform 1 is level with platform 2 and another figure can be placed standing in front of the opposite door, making sure he fits through. Taking another line back to the vanishing point, I can place more people along this side of the platform where the heads touch the eyeline (see right).

Another approach is to take a sheet of clear acetate and draw a figure on it in pen. This can then be manoeuvred in a scene to find the correct placement.

Below is an ink drawing of a square in Bath, Somerset, UK. The ground slopes downhill towards the arched building, so the people's heads are slightly lower in each layer going into the distance.

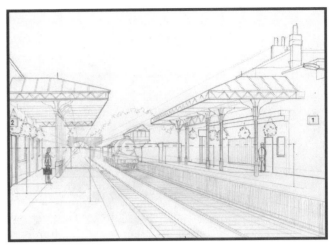

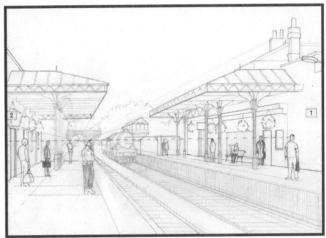

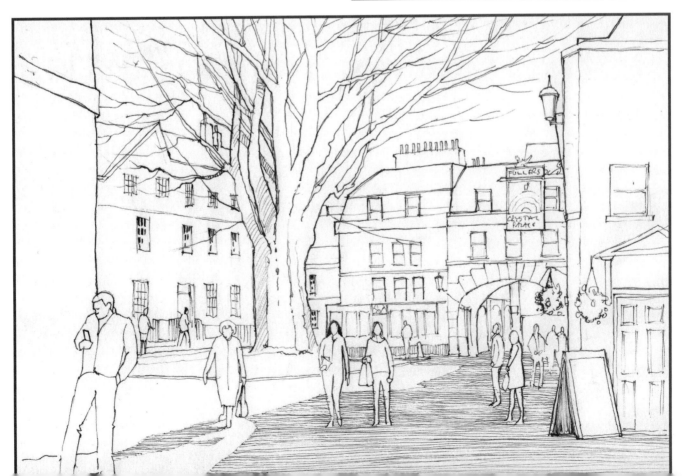

PERSPECTIVE IN FIGURES

Perspective in figures often only becomes apparent when we take an unusual viewpoint. Looking down on people from a high window makes the body taper dramatically. If we seat ourselves near the feet of a model in a life class, the feet look disproportionately large. Often, the only way we can render these poses realistically is to measure carefully and make comparisons of the relationships of different parts of the body.

Using the mannequin, we can understand this action by drawing a rectangle around the figure and then dividing the space into quarters (see right).

In the diagram below left, I've drawn the same box with three vanishing points. VP3 is placed closest so that the box tapers dramatically. I then divide the space into four using drawn diagonals. Note how closely the centreline appears to be to the bottom of the box. Drawing the mannequin into this space using the dividing lines as reference gives the impression of a bird's eye view, as though we're looking down on the subject from a high window.

The drawing at bottom right shows a different viewpoint with the feet nearest the viewer.

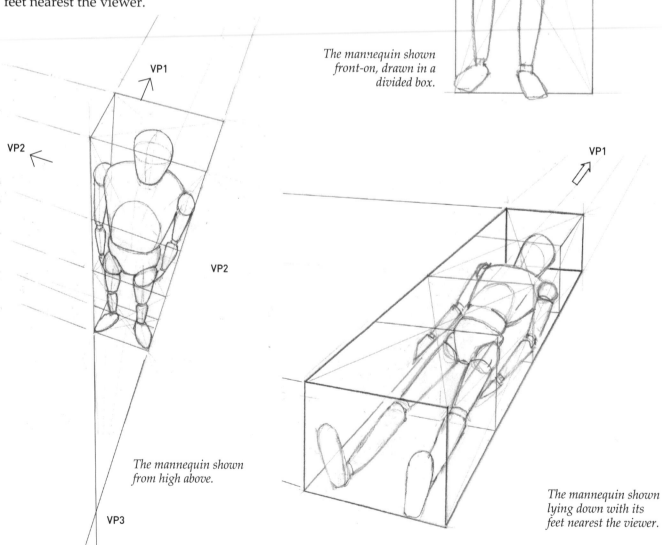

The mannequin shown front-on, drawn in a divided box.

The mannequin shown from high above.

The mannequin shown lying down with its feet nearest the viewer.

62

PERSPECTIVE IN FACES

Faces cause very little difficulty with perspective when drawn symmetrically, square-on. Two parallel lines can be drawn through the eyes and mouth and a vertical line down the centre line of the face, which is usually at 90 degrees to the eyes and mouth, as shown right.

A portrait is often more interesting when the subject is drawn slightly turned away from us, but then perspective comes into play. As the head turns, the parallel lines running through the eyes and mouth go to a vanishing point. Here the line of sight of the artist is placed midway between the subject's eyes and mouth on the tip of the nose (see below). As the face turns away, one side becomes foreshortened, which can be seen by comparing the cheek widths A and B.

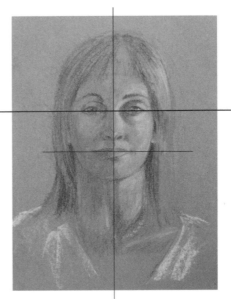

A face drawn square-on.

A face turned slightly away from the viewer.

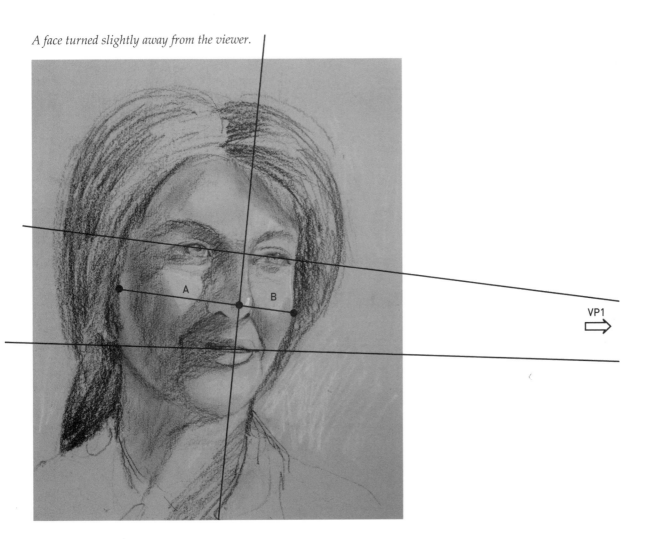

VP1

Animals

Placing animals within a landscape can often cause difficulty in terms of scale and position. Most animals can be substituted for a box or rectangle of approximately the same dimensions as the creature itself, as shown on this page.

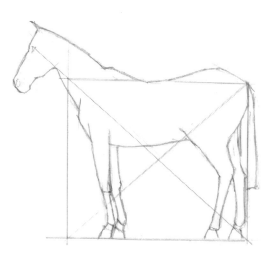

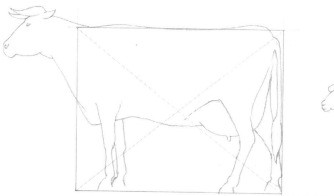

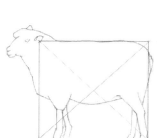

Animals can be broken down further into a series of geometric shapes. Then you can add converging lines going to vanishing points (see below). Note that when looking down on an animal such as a dog, our head and eyeline will be higher, causing converging lines to slope uphill from the animal.

Eyeline

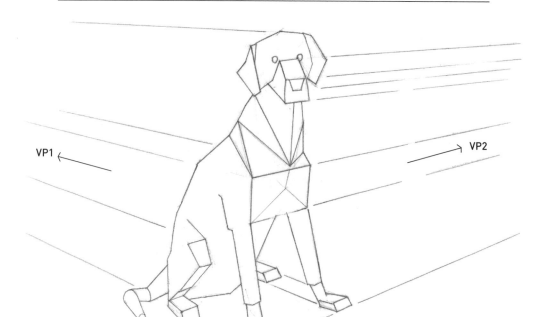

VP1

VP2

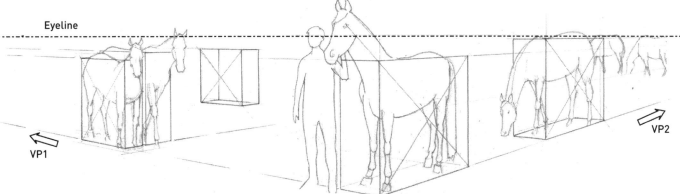

Adding animals convincingly into a flat landscape requires a reference or starting point. Adding a person gives a useful height guide if it is drawn standing next to an animal. On a horse, an adult's head will lie somewhere between the eyes and the nostrils of the animal. Using the human head as reference, an eyeline can be drawn across the paper. You can then draw boxes the same proportion as the horses in various positions, with the edges converging on vanishing points off the paper to the left and right. Once the boxes are lightly added, the horse shapes can be drawn within the space (see above).

The diagrams right and below show the action of perspective on a pair of shire horses. When harnessed up, they form a natural box to which perspective lines and vanishing points can be attached.

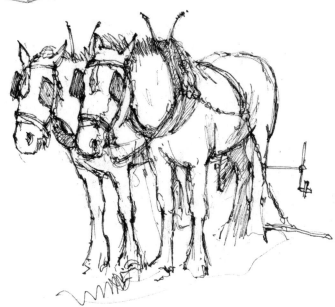

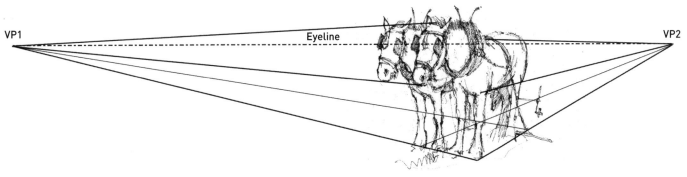

Sheep are about half our height, so when we stand in front of one, our eyeline is higher than that of the animal. Taking lines to a single vanishing point and comparing the width to the length of the enclosing box demonstrates just how foreshortened the animal appears to be (see right).

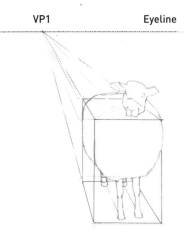

PLACING ANIMALS IN A LANDSCAPE

Placing creatures in an empty landscape can be done convincingly by going through a few simple steps.

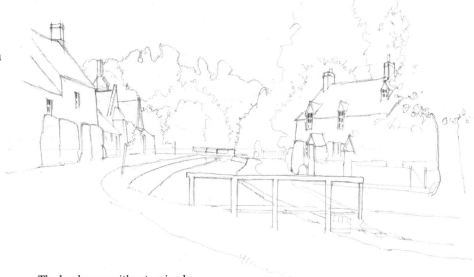

The landscape without animals.

1 First we must discover where the eyeline is. This can be done by projecting the converging lines of the buildings to the left or right to see where they meet. A horizontal line through this point gives the eyeline.

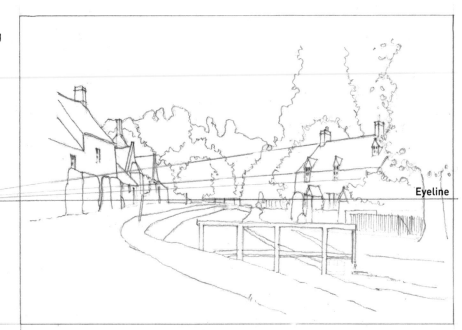

VP1

Eyeline

2 Next I place a person standing on the bridge, making the head level with the eyeline. The height relationship of the handrail shows the person is not out of proportion. I choose to add a gaggle of geese into the foreground. A goose's head comes about to the top of an adult's thigh. I mark this on my drawn figure and project two parallel lines the height of a goose across the road.

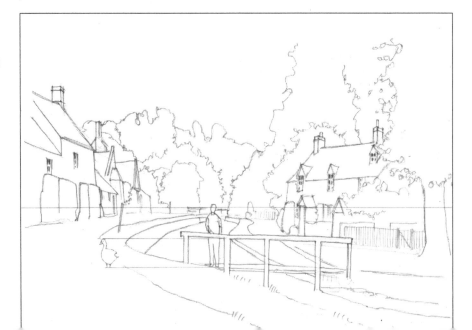

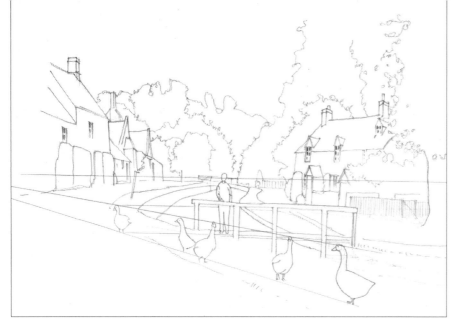

3 I can then take two converging lines back to the vanishing point on the left, just off the page. Projecting these converging lines to the right, I get the scale of the bird in the foreground. Three more geese are added along these converging lines.

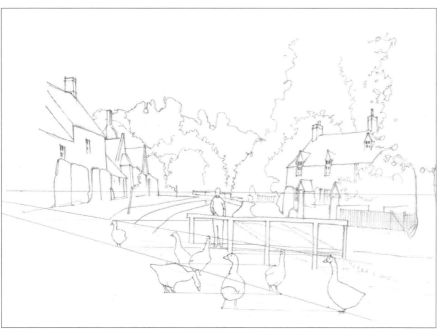

4 I then add a couple of horizontal lines to allow me to draw two more geese in a slightly different position. Once the projected lines have been added, it is often easier to match converging lines by drawing the goose onto tracing paper and sliding it over the paper surface.

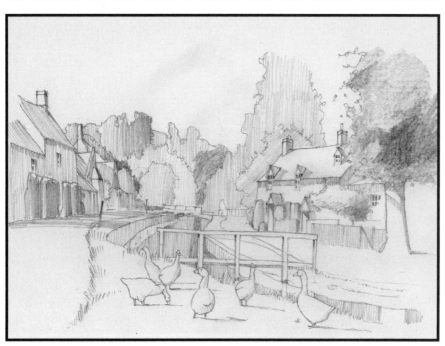

The drawing can be completed by removing any unwanted items and marks with an eraser and erasing shield. I removed the person and the first goose, which were drawn in for reference only, to help with scale and perspective.

Boats

USING A FIGURE OF EIGHT

Drawing boats, although challenging, is basically no different to drawing say, animals in perspective. The main area that gives artists a problem with boats is that the curves on the upper edges appear to go in two different directions. When we view a small rowing boat from the top and side, we see these two sets of curves in action (see right).

A simple approach to drawing these curves is to create a flat figure of eight (see below). This can be used to create a front view or a view from the stern. If we use this shape, it helps to give the subject a sense of perspective. If the loops are drawn too round, the boat can look odd and unrealistically foreshortened.

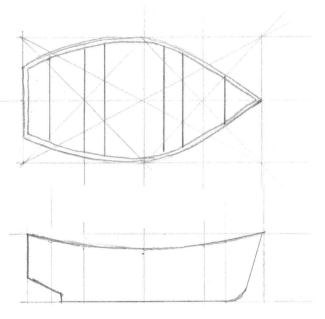

A rowing boat from two angles, showing two sets of curves.

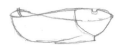

I have redrawn the boat with a number of different viewpoints A–E (right). Alongside, I have added the correct shape made by the upper edges of the boat. The first image, A, is as if we were underwater, gazing up at the boat floating on the surface. E is the opposite and we are looking down on the boat from a high quayside. Note how, when the viewpoint changes to a much higher or lower one, the figure of eight disappears, to be replaced by a more open shape.

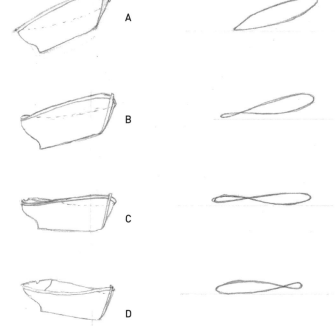

PLACING THE SUBJECT IN A BOX

Shown below is a boat drawn within a box. The most common way of working is to have two vanishing points to create the box, though a single vanishing point would suffice. I have chosen a high viewpoint so that we can see the seating inside the boat. After drawing the box, I divide it into quarters and find the centreline for the keel. The front of the boat touches the front of the box and then slopes back to the keel. After drawing in the keel, I note and draw the position of the rear of the boat. Finally, the top rim of the boat is added. I also add a shaded area where the waterline comes up to the boat which is about halfway up the side of the box.

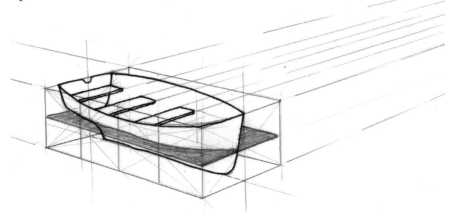

LOOKING FOR SMALL SHAPES

Although the boat shown below has a strong figure of eight shape, sometimes a more successful drawing can be made by concentrating on the small abstract shapes made by objects within the hull, or patterns created by criss-crossing ropes on the exterior. If you concentrate on these shapes, the perspective seems to take care of itself, and by connecting the shapes together, you can draw a convincing boat.

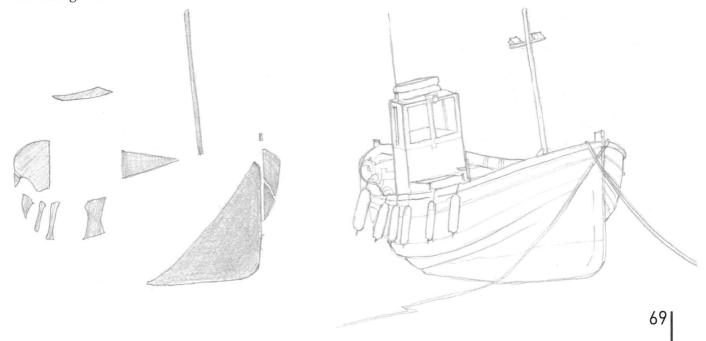

PLACING BOATS WITHIN THE PICTURE PLANE

When multiple boats are moored or stranded, they tend to settle into positions that are often no longer parallel to each other. These shapes then create multiple vanishing points depending upon their orientation to the viewer.

 The picture below shows a stack of boxes that have been turned so that the edges are no longer parallel to each other. Box B has a new set of vanishing points, one of which has now gone off the page. Box C has been turned into such a position that it now has a single vanishing point (Third VP). Note that all the lines converge to the same horizon, which is dictated by the viewer.

This drawing of Burnham Overy Staithe shows beached boats in various positions. Finding the eyeline can be done from the buildings perched higher up. However, the boats are in a different position to the building I have chosen, creating some new vanishing points going to the same horizon. I have drawn boxes the same proportion as the boats and positioned them on the beach and then added boats inside the boxes.

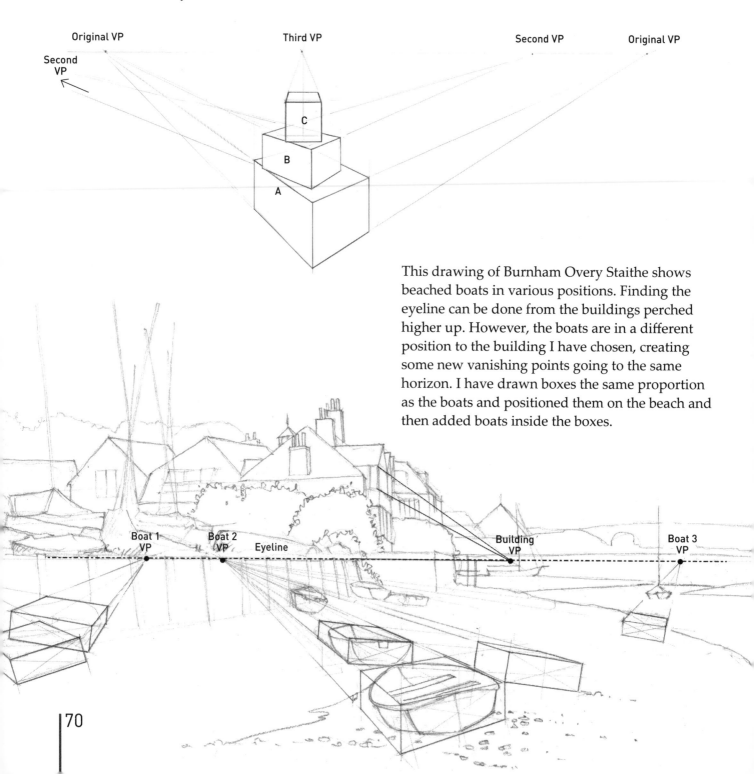

Cala Corp

This drawing shows a group of yachts moored in the bay. The bay is essentially a flat surface which, through perspective, appears to rise into the distance. This can be seen by the difference in height of the near and far shores.

When drawing boats in this type of setting, observe where the shore cuts through the boat, as this offers a good reference. The correct scale can be achieved by comparing the boats to other objects in the scene. Mast height is important too. Often these are drawn too short. Look at how far each boat's mast projects into the sky.

I added another boat in the foreground space. Starting with a box the same proportions as the boat, I took the converging lines to the same vanishing points created by the clifftop buildings. I drew only the upper part of the hull, to give the impression that the boat is floating.

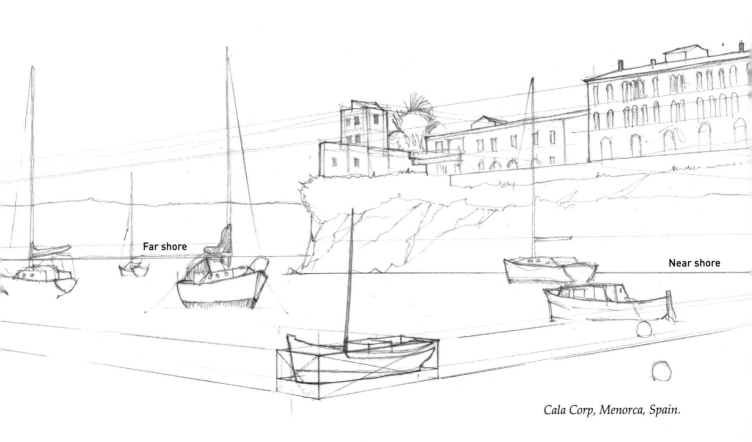

Cala Corp, Menorca, Spain.

Shadows

I find that adding shadows to sketches adds solidity and form to a subject that, until then, was just a collection of lines describing the shape of the scene. Usually, I start with an ink drawing, after which I add the shadows, sometimes working away from the scene, without reference. I usually invest twice as much time when applying the shadows as in the line work.

Low light levels make any topic flat and less interesting. The subject can be given quite a boost by adding shadows and tone retrospectively. It is useful to have some idea as to the way shadows and light direction behave so that shade can be applied convincingly.

Looking through my sketchbook, I light the majority of subjects from the right so that shadows are cast across the page to the left. I also find that bathing small areas in light and having larger areas in shade is quite effective.

At first, confine yourself to simple subjects such as an object placed against a wall on a sunny day. It is more comfortable to work with the sun behind you, as long as you protect the back of your neck from heat.

Light can come from any direction in a sketch. Below is a house drawn with two vanishing points. VP2 goes off the page to the right. I've chosen to place the light source high up near the centre of the paper. The light position will dictate the length of the shadows. A light source will have its own vanishing point, which is placed on the ground directly underneath (SVP or shadow vanishing point). I've placed this one on the far horizon.

The shadow of the building can be plotted by drawing a series of straight lines: A, B, C and D from the light source through the upper edges of the house. Another set of lines can be taken through the lower corners where the building touches the ground back to the SVP. The apex, D, needs a vertical line dropping to the floor through which another line can be drawn back to the light source. As this is the highest point, this line provides the longest part of the shadow. The intersections of the two sets of lines can be marked with dots. Join the dots and the shadow outline is created. Note that these cast shadows can be any shape depending upon the position of the light.

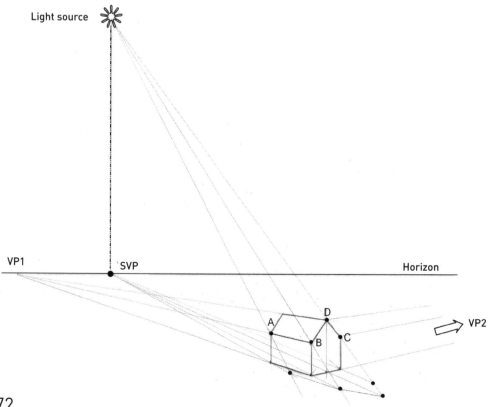

In the drawing below, I added more buildings in different positions. Using the same principles as before, I plotted the shadow shapes on the ground with all the edges going back to SVP. With House 1, the two walls are in shadow, though I added less shading to the left-hand wall as it is slightly turned towards the light source. House 2 is almost completely backlit, so I applied almost the same amount of shading to each wall. House 3 has its right-hand wall turned towards the light source, so here I just shaded the back wall. To make the shadows more convincing, I made the cast shadow lighter as it gets further from the subject. For the form shadow, I varied the shading. On Houses 1 and 2, the shading starts off dark near the apex and then gets a little lighter as it nears the floor. This helps to separate the form from the cast shadow and also suggests that some reflected light is dissolving part of the shadow near the base of the building.

I populated the ground plane with figures to show the effect light has on them. The length of the shadow can be plotted by taking a line from the light source through the head of each figure. Take two lines through the legs back to SVP, and where the lines intersect gives the length and direction of each shadow. Note how the shadows get shorter on the people nearer the light source. It is worth bearing in mind that aerial perspective comes into play here too, so as the people get further away, there should be less strength or contrast in their shadows.

Tip

Shadows that fall on the ground are called cast shadows, while shadows on the wall of a building are called form shadows, as they describe the shape of the object.

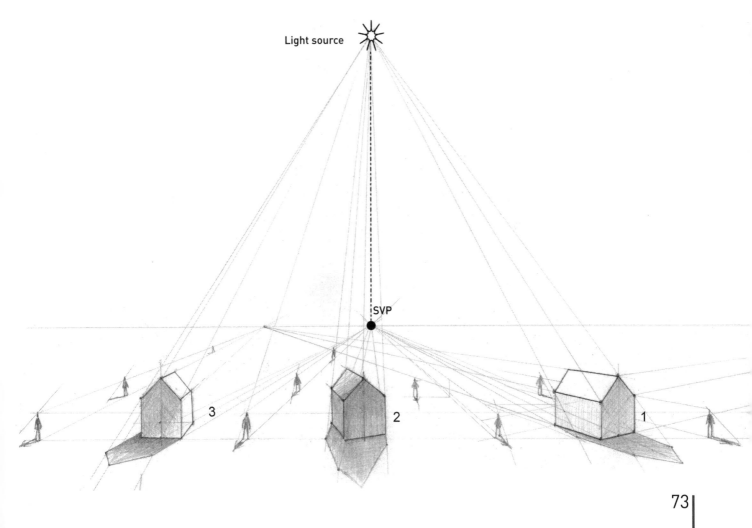

Light source

SVP

3

2

1

73

SKETCHING SHADOWS

Sunny summer evenings or early mornings are a good time to sketch. The shadows are elongated because of the low sun, creating more interesting compositions. One of the surprising things is how quickly the sun seems to move after you have become absorbed in a sketch. Before you know it, that perfectly lit subject has become bland and uninteresting as the sun moves around the sky. I find that light and shadow can be captured quickly by working small. The thumbnail sketch of a street in the village of Wing in Rutland, UK, measures just 10 × 7.6cm (4 × 3in). The tree shadows cast over the roadway help to describe the shape of the embankment as they curve over it.

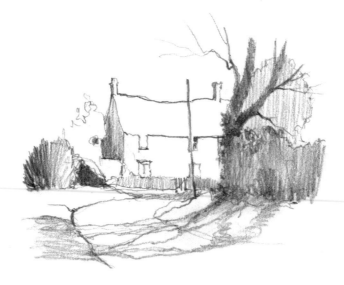

A quick sketch of the village of Wing, Rutland, UK, showing tree shadows.

This is another 10 × 10cm (4 × 4in) sketch of the same village. I was particularly interested in the large yew tree in front of the house and how this shadow mixed in with the cast shadows of the building itself.

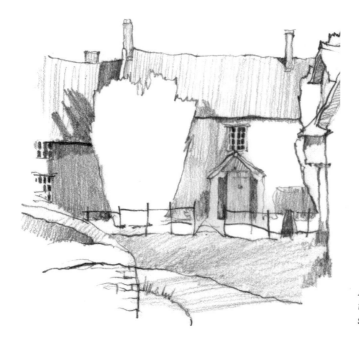

Another sketch done in the same village, with the shadow of a yew tree.

74

For the small sketch of Exton in Rutland, UK (right), I concentrated on the abstract shapes formed by the cluster of buildings, starting with a small shadow shape and placing one next to the other. With sketches like this, if you ignore most of the lines and concentrate mostly on form shadows, the perspective will take care of itself.

This cottage in Winsford in Exmoor, UK, was a larger sketch of 25.4 × 17.8cm (10 × 7in), which started out as a loose ink drawing using fibre-tipped pen. Although the sketch is larger, I still worked quickly to capture the light. The long, deep shadows on the roof give a good indication of light direction and the length of the shadow on the left-hand side of the cottage.

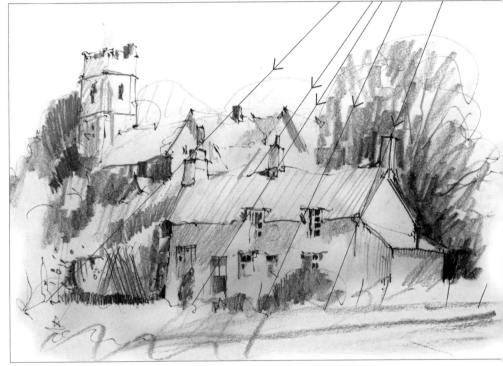

This is the same cottage, but I've moved around to a different viewpoint. After an hour or so of sketching, the sun has moved and the shadows have changed position.

Reflections

There are some incredible effects caused by reflections and the behaviour of water. Reflections on still water are not as exciting as those abstract shapes and patterns created by the movement of wind and water, but they are very useful to study.

The top diagram below shows a figure observing a reflection from a river bank. The ray of light leaving the object and approaching the water's surface is known as the incident ray. The ray of light that then leaves the surface and goes to the viewer's eye is known as the reflected ray. At the point X, where the ray strikes the water's surface, the two angles created are equal and are known as the angle of incidence and the angle of reflection.

A good rule to remember is that the object reflected in the water is seen as far below the surface as it exists above it.

The bottom diagram below shows a group of buildings at different distances from the water's edge. The vertical from each structure needs to be brought down to the reflecting surface and then continued just as far below it. Point A represents the water's edge. Measuring up to the edge of the roof and then plotting the same distance downwards gives the depth of the reflection. Taking a line from this point back to VP1 gives the position of the reflecting surface in relation to the other buildings in the distance. More dots can be added along this line to plot where each structure meets the reflecting surface. These can then be plotted the same distance downwards. The figure is too far from the water's edge to be reflected. The reflection of the quayside is in the space where it would be.

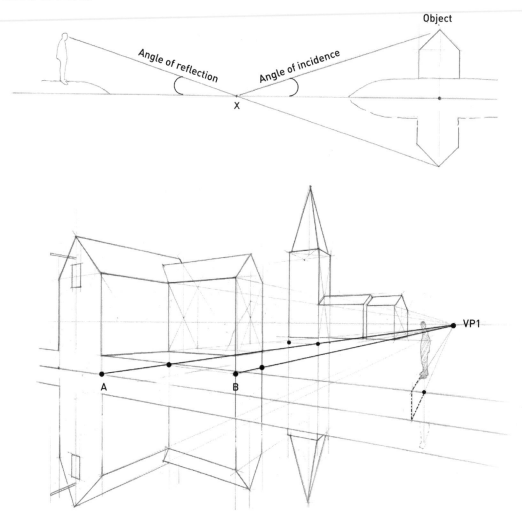

This punt and fisherman (below) lend themselves well to a two-point perspective drawing which also gives some good guidelines to how to lay out the reflection in the water. For the position of the fisherman, I have predicted how far down the boat he is sitting, then taken a line back to VP2 for the reflecting surface. I can then measure downwards and plot an equal distance for the reflection.

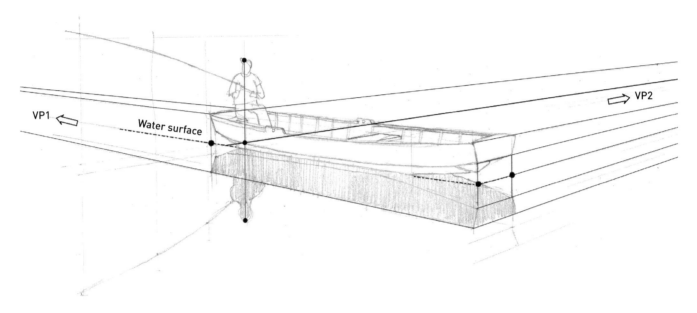

Now that I have the reflections nearly correct, I break up the edges with a plastic eraser and drag out some lights through the reflection to give the effect of water movement (see below). If you use this technique, the reflection need only be nearly correct to still look convincing.

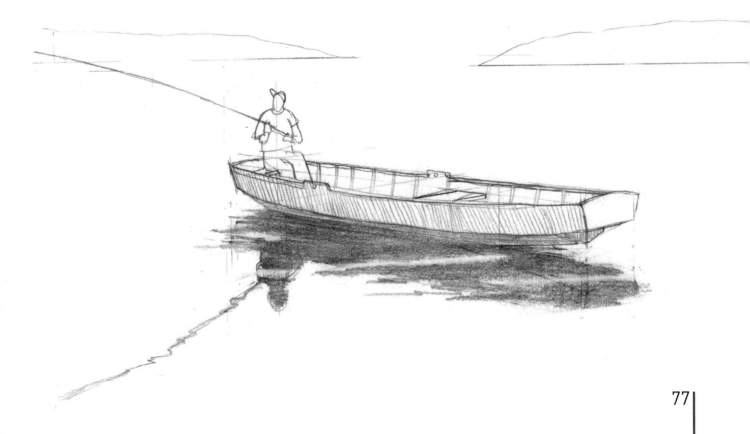

BRIDGE OVER THE RIVER NENE

When adding reflections to a subject, drawing the main object first provides a handy reference to work from when adding reflections, as shown in this step-by-step demonstration.

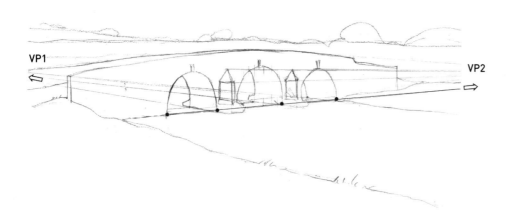

1 I have drawn the bridge with vanishing points to the left and right, off the paper. As the bridge consists mostly of curved surfaces and the top of the arches are different heights, there are not too many lines to plot other than the tops of the buttresses and the base of the arches. Once the outline drawing is complete, I can find the surface of the river by drawing a straight line where the two edges of the nearest arch touch the water. As the edges of the remaining arches are not clear, I can take the straight line through the drawing and back to VP2.

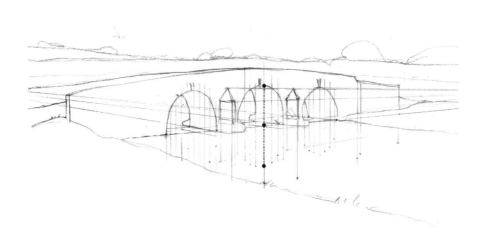

2 Next I drop a series of vertical lines and make them the same depth as the height of the bridge at the waterline. I can now plot the curve of each arch in the water. I also plot some points for the reflection of the parapet.

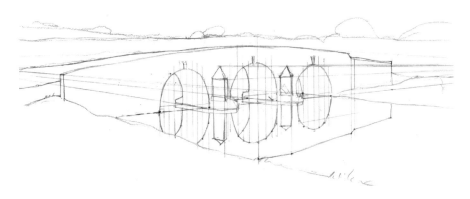

$\mathcal{3}$ When I have enough points, I can join the dots to create the outline of the reflection.

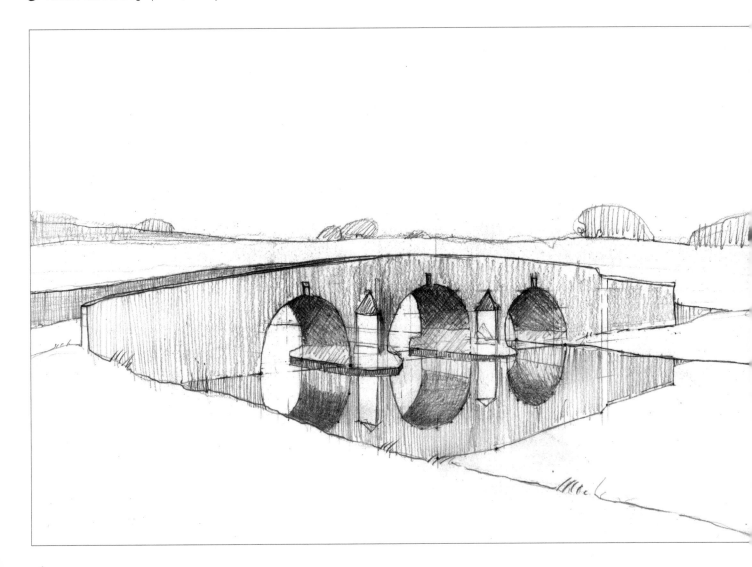

$\mathcal{4}$ After removing any unwanted guidelines, I proceed to shade in the surfaces. The day has a flat light with very little shadow. I note that the shadows under the arch and in the reflection get lighter as they near the reflecting surface. I make the shadows in the reflection a little darker than those on the underside of the bridge. When tackling this type of subject, it is worth noting the strength of reflections, as this can vary with the time of day. Sometimes reflected light from the water can make the shadow under the bridge almost disappear.

Skies and seas

SKIES

When we talk about skies, what we really mean is the arrangement of clouds in what would otherwise be an empty space. Without the addition of clouds in a drawing, sketches lack tonal balance and interest. Clouds have been categorised by meteorologists into a number of different classes based on their shape and behaviour.

Cumuli are the rounded masses of glistening white clouds that in fine weather can be seen against a blue backdrop. Artists tend to draw these as isolated balls of cloud, whereas they are often better seen overlapping in the distance, with heaped upper surfaces and flat beneath. The presence of perspective is not always readily appreciated until we observe the lessening in width, depth and size as they recede towards the horizon.

Cirrus or feather cloud is the type that, next to cumuli, attracts the attention of the artist. They are delicate feather-shaped clouds that are seen as drawn-out lines that extend high up over the entire sky. Each line appears to be going to a meeting point straight ahead of us.

Cirro-stratus are thin, sheet-like, high-level clouds which are relatively transparent. Cross currents can arrange these clouds into very attractive shapes and patterns. It is worth remembering that they will still follow a perspective system in their arrangement in the sky.

Stratus are low-level clouds characterised by horizontal layers and a uniform base. When you are looking up at these clouds, they can have the appearance of a boarded ceiling with the boards running across our vision. The long horizontal stretches of cloud become closer together as they near the horizon. When drawing such a subject, the corresponding closeness of pencil strokes will greatly help the impression of distance.

Norfolk sketch

Norfolk in the UK is a place of large open skies that can provide the artist with fabulous cloud arrangements.

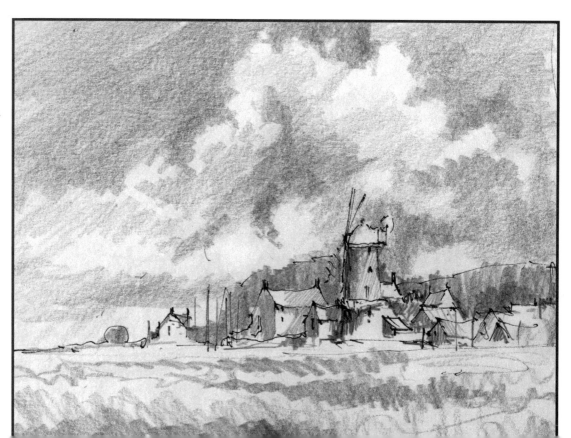

CUMULUS CLOUDS

Cumulus clouds have a puffy, cotton-like appearance with a flat base and lend themselves best to demonstrating how perspective behaves upon them.

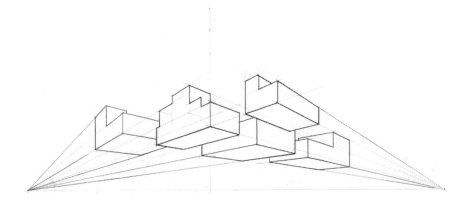

1 I drew a number of random-sized boxes in two-point perspective. They were not completely rectangular, but had smaller boxes added on.

2 I then drew cloud shapes that roughly occupied the spaces and shapes created by the boxes. I added shading to the cloud forms, just as you would darken one wall or face of the box if it were solid.

3 I then removed the boxes.

The finished clouds with the perspective lines removed.

SKY AND SEA FROM LIBERTY ISLAND

In this view from Liberty Island in New York, I selected a single
vanishing point along the horizon where the buildings lie.

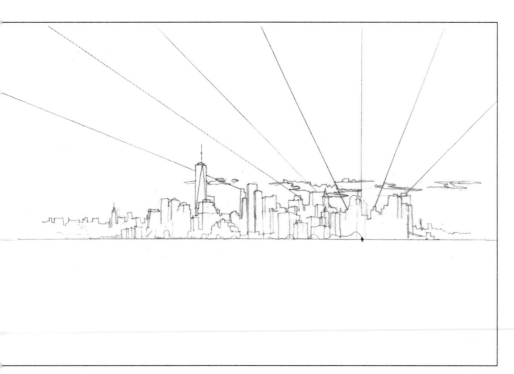

1 From the vanishing point, I drew
a number of lines radiating into the
sky. Using this as a guide, I added a
line of small cirro-stratus clouds across
the skyline.

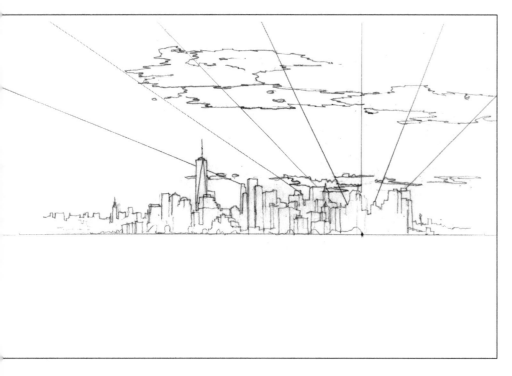

2 I then added larger, flat clouds in
the upper part of the sky, allowing the
guidelines to pass through the centre of
each cloud.

3 I added more clouds, aligning them with the left-hand guideline.

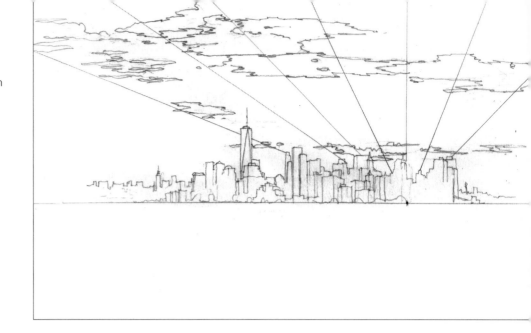

4 After adding sufficient clouds, I removed the guidelines. For the water in the foreground, I ruled a series of horizontal lines which get closer together as they approach the far shore.

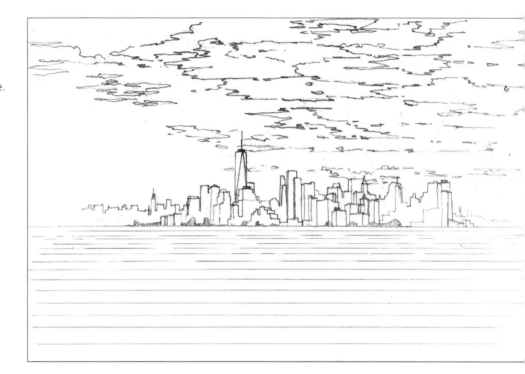

5 The horizontal lines in the water create good guidelines for the perspective of wavelets running across our vision. They appear to get closer together as they recede into the distance. Finally I added the ferry and sailing boats to the scene.

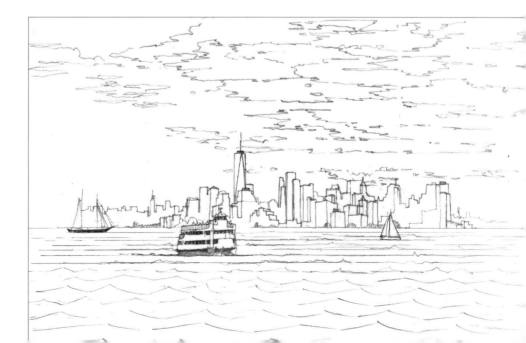

THE CURVATURE OF THE EARTH

When we look at scenes on land, we are not always aware of the curvature of the earth. This is usually because our view of the horizon is interrupted by trees or other objects. When we look out to sea, it is possible to detect this curvature. It becomes more obvious if we watch a ship sailing away from us, as in time it disappears over the horizon (see the diagrams below).

A viewer looking at a boat that appears to have slipped over the horizon.

This phenomenon is governed by how far our eye is above sea level. For someone 1.83m (6ft) tall, the viewing distance out to sea would be just less than 4.83km (3 miles).

This curvature can also be observed when we look along the shore rim. If we take lines along the breakers back to a single vanishing point, they will appear to converge at a point higher than the horizon of the distant surface, because of curvature. As artists, we can ignore this effect and assume the distant surface is horizontal.

The drawing below shows a shore rim with a single vanishing point on the now level horizon, just to the right of the figures. A series of radiating guidelines helps to describe the position of the breakers approaching the shore. The sky is populated with cumulous clouds which I added using radiating lines from the same vanishing point as the wavelets.

What the viewer would see.

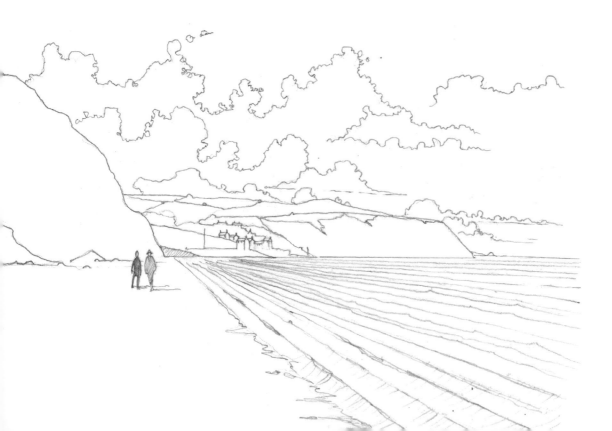

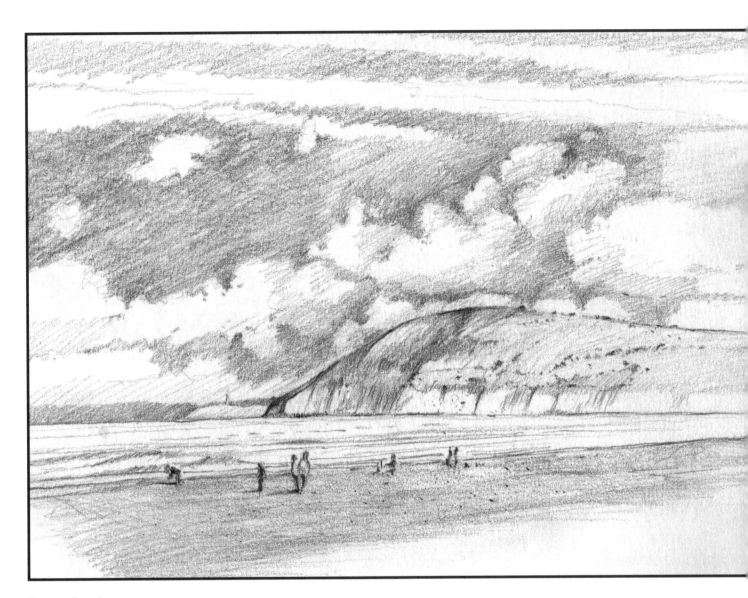

Brean Sands

A sketch of this beach in Somerset, UK.

Above is a view along the beach at Brean Sands. The far shore and
the waterline converge to a single vanishing point off the paper to
the right. In this instance I didn't use any guidelines to complete the
sketch, just observation and the knowledge of how skies and seas are
affected by perspective.

Inclined planes

RECEDING RIVERS AND ROADS

Rivers with parallel banks obey the rules of perspective as they curve and turn across the landscape. Within these naturally irregular curved shapes, water has a flat surface, with all the vanishing points sharing a common horizon.

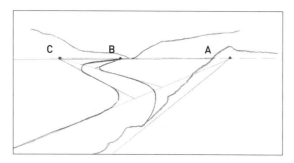

The diagram (above) shows a river snaking across a valley floor. The main vanishing point is formed by the nearer parallel sides of the river converging at a single point on the horizon, A. The two directional changes also have their own vanishing points at B and C. If we can examine the shape the river makes as it occupies the space in our sketchbook, a more convincing subject can be drawn.

The next diagram (1, below) shows the converging basic perspective lines of the Great Langdale Beck that we would see if we were looking along it from one end. The vanishing point A is the easiest to detect, as the parallel sides of the near banks are easier to see. I have added a rectangular picture frame to the sketch to see where these lines exit the drawing, at B and C. This is especially useful when drawing rivers, as they occupy a large area of the paper in the foreground of the sketch. The river changes direction a couple of times, creating vanishing points D and E.

There is a stone wall that follows the edge of the river which runs a line to vanishing point A. Now the landscape can be drawn in (see diagram 2, below). I add a volume of trees on the right where glimpses of the river edge can be spotted. Straight lines or curves along river banks can look unconvincing, so breaking up the edge with a zigzag shape is easier than trying to draw the curves of the river. Parts of the river bank can be made to project into the water, which adds to the realism of the water's edge.

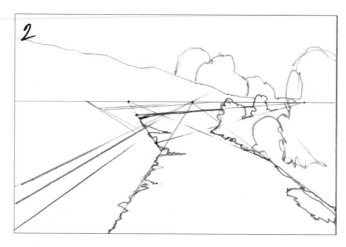

The drawing below (3) shows the finished sketch with shading, reflections and tone added.

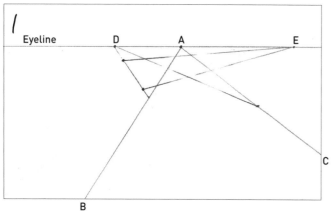

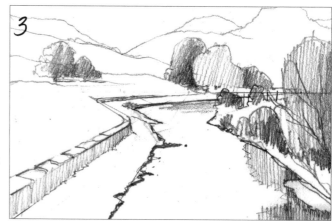

Roads

Curved roads can behave like rivers if they are level as they twist and turn across the landscape. The diagram on the right shows a road that is almost level, possibly with a slight incline uphill. This impression is very much governed by the shape we draw to represent the road.

The next diagram (right) shows the initial shape we would draw for the road in the top diagram. It is important to estimate where our eyeline would be, slightly above the road shape.

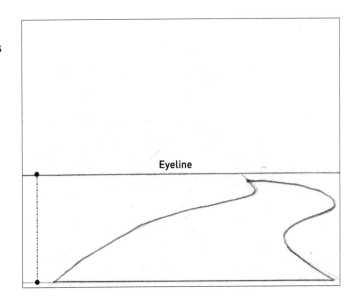

Eyeline

Often we overestimate and place the eyeline too high, ending up with a road shape something like that shown in the diagram on the right. If we surrounded this with the other landscape elements, it would give the viewer the impression that the road was rising uphill.

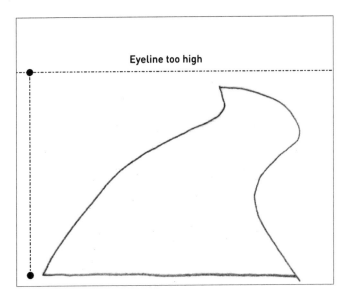

Eyeline too high

SLOPING LAND

The diagram below, left shows three shapes, all the same width, whose bases recede to a single vanishing point, VP1. The first shape has a second vanishing point higher up (HVP) which gives the impression that the surface slopes upwards. The last shape has a lower vanishing point (LVP) which makes this shape appear to slope downwards. The middle shape has everything going to a single vanishing point, and so the surface appears flat.

In the diagram below right I have connected all three shapes going to a common vanishing point, VP1, to create a bridge.

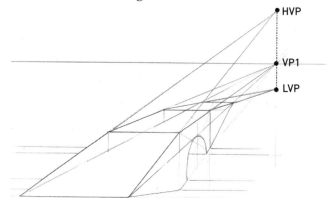

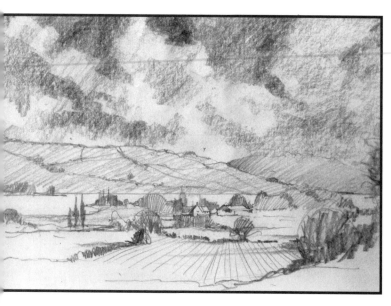

Blagdon Lake

This sketch shows the view across the valley towards Blagdon Lake, Somerset, UK. The farmhouse is too distant to help our viewpoint, so we must look for elements within the landscape to give the impression of perspective and distance. The foreground bush on the right and the edge of the land cutting across the base of the sketch give a feeling of depth as the ground slopes away from us at our feet. Adding converging lines in the ploughed field helps to lead the eye towards the farmhouse feature. The width of the fields become less and less as they approach the lake shoreline. Across the lake, the ground rises up. This slope is emphasised by the distant hedges and bushes, which are more faintly drawn to give that feeling of distance using aerial perspective.

Skinner's Yard, Frisby on the Wreake, Leicestershire, UK

This sketch shows buildings on an inclined plane. All the buildings converge to a vanishing point at VP1. It is necessary to be aware of an additional vanishing point at a higher level, HVP1, to create the effect of the road sloping uphill. The road cuts across the base of the buildings, masking what would be the real base of the building if it were on level ground (shown with dotted line).

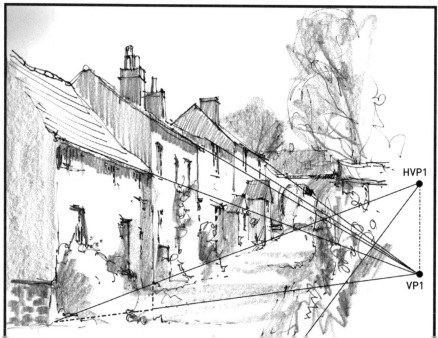

STAIRWAYS

The diagram (below right) shows a stairway that is constructed in a similar way to the uphill shape in the diagram on the opposite page, top left. Line A is projected from VP2, line B from VP1 and line C from HVP1. Where these lines meet forms the edge of the stair. A vertical line from this intersection forms the upright and where this intersects C, it forms the top of the tread. Taking a line from the top of the tread back to VP1, the whole process can be repeated until the last stair is complete. This is worth tackling as a drawing exercise to reinforce the process of constructing steps on a rising plane.

The diagram on the right shows stairs from the side. Lines A, B, C and D are all parallel to each other and touch the tops and bottoms of all the treads. Lines are then taken back to VP1 from all these intersecting points to form the stair shape. To create a more interesting stairway, lines A, B, C and D could all be made to converge at a higher vanishing point high up to the left of the paper.

Harbour Slipway, Staithes, Yorkshire, UK

This is a harbour scene with a slipway and stairs leading to the beach. Two vanishing points are established off the paper, VP1 and VP2. These allow the construction of the buildings and harbour wall. The slipway and stairs need a second higher vanishing point, HVP1, for their creation. The stairway is constructed using the same method as described at the top of this page. The harbourmaster's hut has not only vanishing points at VP1 and VP2 but also a higher vanishing point at HVP2, as the roof of the building acts like an inclined plane with the back edge tapering towards vanishing point HVP2.

Curved perspective

CIRCLES, ELLIPSES AND SPHERES

It is worth practising drawing circles. Start with small ones, gradually enlarging them until it gets to the point where construction lines are needed. This will give you an idea of how large you can draw a circle freehand.

A useful technique to use where an accurate circle is required is to make the hand behave like a set of compasses, keeping the pencil stationary and rotating the paper (see top right). Hold the paper down firmly with the middle finger and grip the pencil between the thumb and forefinger. Use the other hand to rotate the paper, making sure it can move freely, without obstruction, and then touch the pencil on the surface. With practice, some quite good circles can be produced. Try using different parts of the hand for a pivot, say the little finger joint or the base of the palm for larger circles.

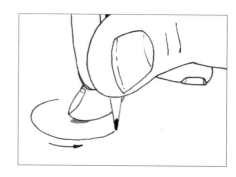

Using the hand like compasses.

From circle to ellipse

A circle will fit into any square we draw. It is the shape of this square when under the laws of perspective that influences the shape of the circle, which then becomes an ellipse. In most instances, it is useful to create a square under the correct perspective conditions and then draw the circle freehand into it. The axes of the square control the shape of the circle and the line drawn is not as free as one drawn without any guidelines.

Diagram A, middle right, shows a concentric circle in a flat plane or a plan view. I have divided it into eight parts, by adding diagonals first and then dividing the centre where they meet. Drawing a circle in this space with compasses, I can see where the circle intersects the dividing lines. I have shaded in the spaces outside the circle, as seeing these shapes makes it easier to freehand draw a circle.

Diagram B, bottom right, shows the square in perspective with the left and right edges going to VP1. The other two edges are parallel to the base of the paper. As the circle drawn in this space is no longer accurate, it becomes an ellipse. The perspective of a square makes the front half look larger than the back and this is also true for the ellipse. So when freehand drawing the circle, draw the front half first. Where the half-circle touches the diagonals, take a line through this point and back to VP1 to mark the position on the diagonal at the rear of the square. The rear half can then be drawn in. It takes some practice to get the ellipse shape right. Early attempts can make the curve on the near and far edges look flat and the curve on the left and right side look pointed.

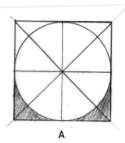

A

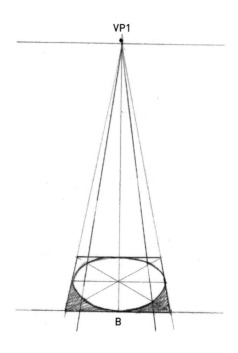

B

Spheres

Drawing a sphere is a progression from drawing a single ellipse.
Construct a cube in two-point perspective. I have divided the cube
into eight smaller sections by dividing each square in half, and created
a freehand circle in the flat plane. A second circle is then drawn in the
vertical plane, crossing the first drawing.

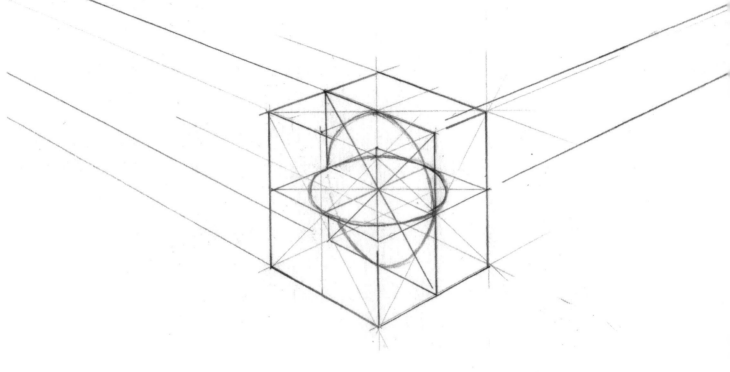

These two shapes are then encompassed with a third circle to complete
the drawing and shading is added.

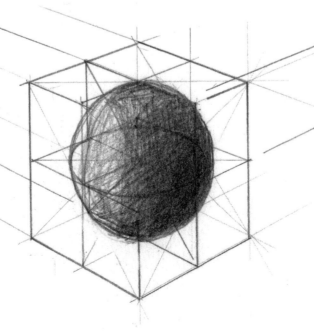

DOMES, WINDMILLS AND TOWERS

A lot of domes that we see are basically a sphere cut in half (see A). We could take a sphere and erase the bottom half and be left with quite a convincing dome. In some cultures the domes are a different shape, more like an onion (see B). Observation will tell us what shape the subject is.

When we look upwards to draw a subject, it is useful to imagine where the ellipse at the base of the dome lies. At this point we see a large ellipse (see below). As we look higher up the dome, we can detect more ellipses that become gradually narrower.

A

B

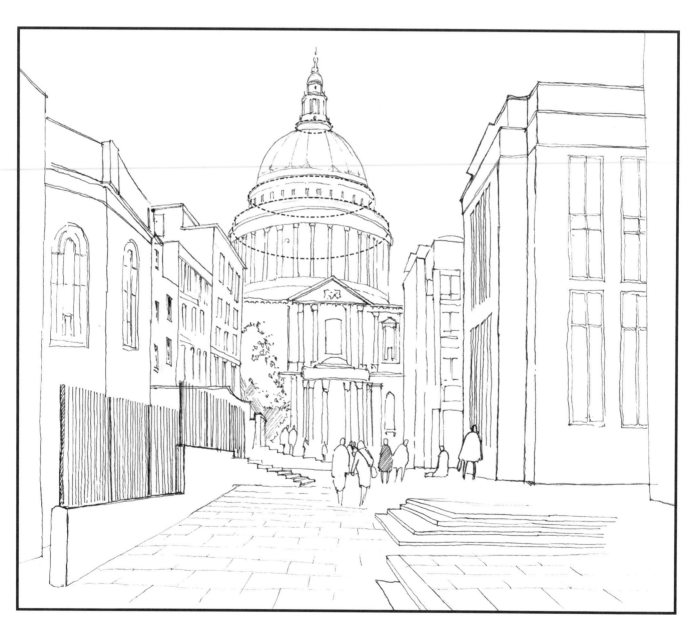

St Paul's Cathedral, London, showing the various sized ellipses that make up the dome.

92

This diagram shows a lighthouse. I started this drawing by placing a figure next to the building to establish an eyeline at the right scale and then a vanishing point in the lower centre of the tower. The base ellipse was constructed in the same way as in diagram B at the bottom of page 80. At the top of the tower is another smaller ellipse which goes back to the same vanishing point as all the other ellipses higher up. Once drawn, the edges can be connected to create the lighthouse.

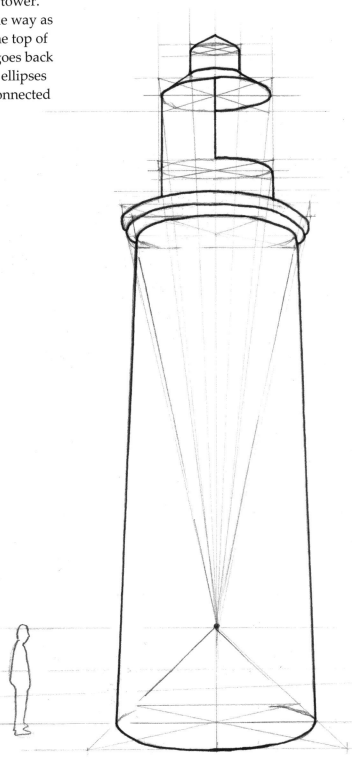

93

Wymondham Windmill

This disused windmill in Leicestershire, UK has an onion-shaped top with the sides bulging out slightly. When constructing such a subject, an indicator in pencil of where the ellipse goes is useful to get the true shape before inking in. Here I added a series of ellipses descending down the tapering cylinder towards the eyeline. Note how they become more squashed as they get lower. An ellipse on the eyeline would appear to the viewer as a straight line.

Once you have mastered drawing ellipses, it opens up the opportunity to draw all sorts of round and curved items, such as pots, bottles, jugs and bicycles, as well as buildings like the one shown below.

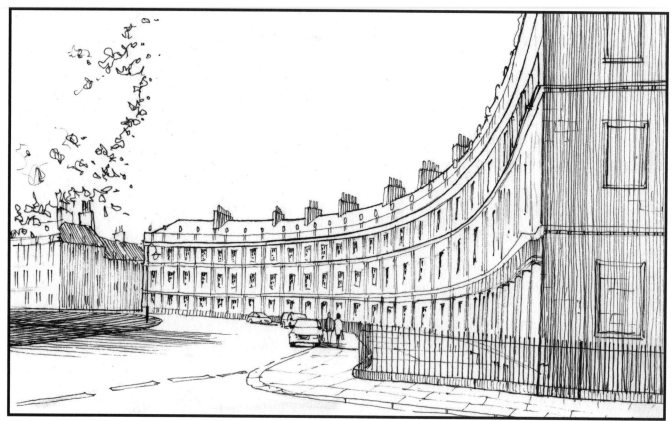

The Circus, Bath, UK

This curved structure is one of the many fine architectural examples to be found in this city. The drawing is done on Bristol vellum board in 0.3 black fibre-tipped drawing pen over an initial rough layout in 3B pencil.

CURVILINEAR PERSPECTIVE

This way of working uses curved perspective lines instead of straight ones back to a vanishing point. The method approximates the image which appears on the retina of the eye, which is spherical. It uses four, five or more vanishing points. Working this way offers a much wider field of vision and in my view is more interesting, fun and quirky than straight-line perspective systems.

Setting up a surface for multiple vanishing points is quite time-consuming. The finished work can look tight and it is sometimes difficult to fit the composition within the construction lines.

The drawing below is a scene along the canal in Venice. Within this circular composition are five vanishing points. I have built up a series of curved construction lines to act as a guide. All the lines going from North to South and East to West are curved. Lines converging on the CVP (central vanishing point) are straight. Setting up a background of guidelines for the drawing is quite involved but once this is complete, it can be used for several drawings with the aid of a light box. The systems can become even more complicated when working with more vanishing points.

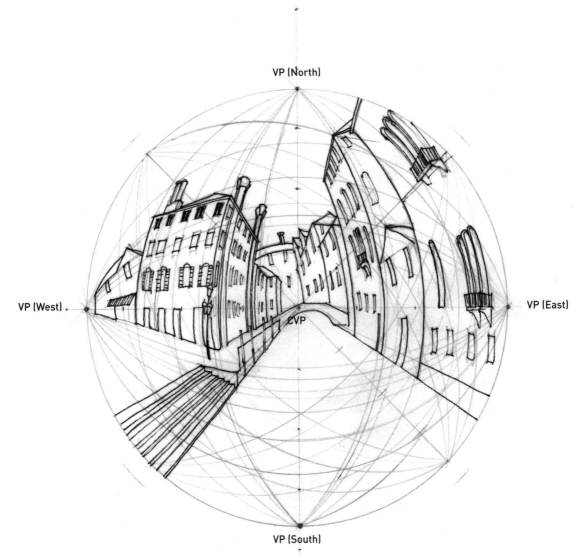

VP (North)

VP (West)

VP (East)

CVP

VP (South)

I prefer to use a more intuitive method which moves outside the constraints of fixed vanishing points. This opens up the scene and provides flexibility and ways of viewing the world that straight-line perspective does not offer.

I have devised several underlying line styles that I try to adhere to when working, usually starting with a very loose pencil drawing that emulates the underlying pattern. As long as most of the lines in the image echo the underlying structure, some cohesion can be achieved. The structures are as follows:

Circular motion.

Waves.

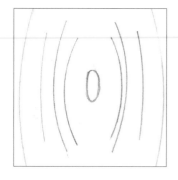

Fish eye or bull's eye.

Rapidly converging or expanding lines.

Winding river or road.

Vase or grasses.

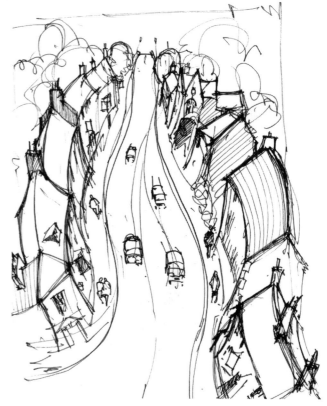

This pen sketch of Burton Street, Melton Mowbray, Leicestershire, UK, uses the underlying idea of the winding road. There are no fixed vanishing points, though I have placed the horizon quite high up the paper, taking a 'helicopter view' of the scene.

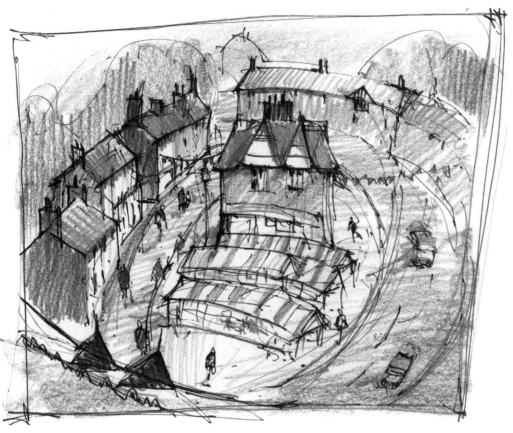

Another helicopter view of Melton market. This time I have used the fish eye as an underlying shape.

This view (below) down the Abbey steps at Whitby in Yorkshire, UK, has the underlying pattern of a wave as the steps dip and curve down the slope and the distant harbour moves up and down across the page. Some of the buildings behave like a vase or grasses. Perspective is still acknowledged in these scenes – things still get smaller as they get further away – but it is fun to bend the rules a little to produce interesting subjects.

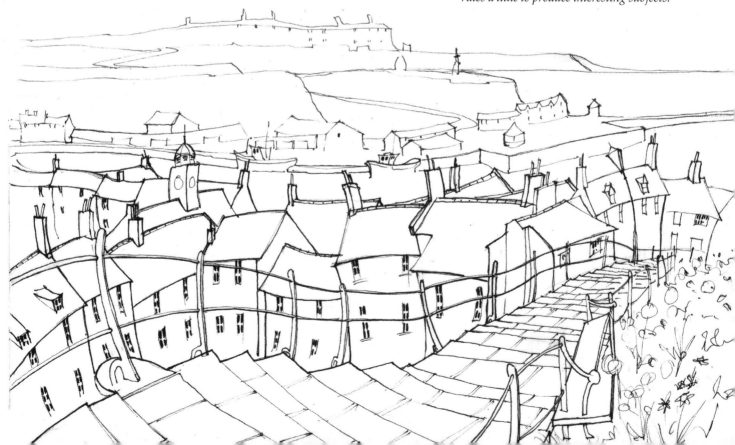

Common mistakes

These are the most common perspective mistakes that I often witness when running art workshops that have an emphasis on drawing.

1 Taking a helicopter view

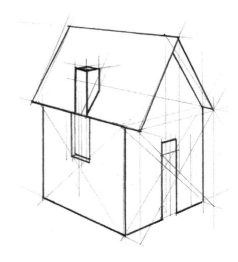

Ask anyone to draw a house without any reference and they will nearly always take a high viewpoint. In this situation we are able to see much more of the roof and even sometimes down inside the chimney. Most of us are used to viewing buildings from street level and in this situation, the guttering will always slope downhill. To remedy this, check the guttering with an angle finder or take a pencil and slide it along the guttering line. There is another mistake on this drawing – though not a perspective one. I positioned the window below the chimney which would make it difficult either to light a fire or see out of the window!

2 Too much depth

When an object is foreshortened into a scene, careful measurement of its depth must be done. In this instance the door and windows remain the same width as they recede from our point of view. This has had the knock-on effect of making the building longer to fit them all in. I usually establish the depth of the building before adding the windows, remembering that they must become narrower and less detailed as they go further away.

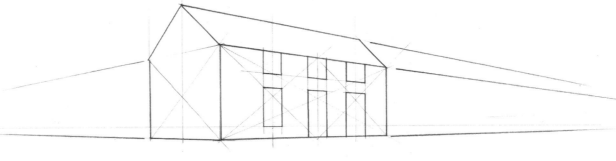

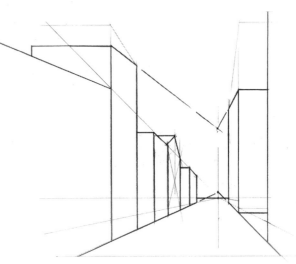

3 Changing angles

When we view a line of buildings down a street, two things tend to happen. On the nearer buildings, we flatten the tops, effectively creating a new vanishing point higher up. On the base, the angle increases as we ignore the vanishing point on the horizon and take the lines to a point just above it, giving the impression that the road slopes uphill.

4 Vanishing points too close

Objects become distorted when we bring the vanishing points in too close (try turning the picture below upside down). This often happens when both points are on the paper. Work on a drawing board with a larger piece of paper so that you have somewhere to project the vanishing points to.

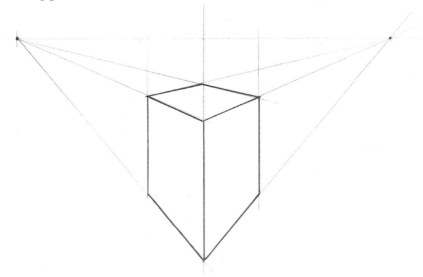

5 Changing eye level

This picture shows a table with two horizons, almost as if the artist had sat down to finish the work. The result can be visually misleading, making the table top look too long and appear to slope uphill. Try to maintain a fixed eye position when referencing a subject to help maintain a consistent drawing.

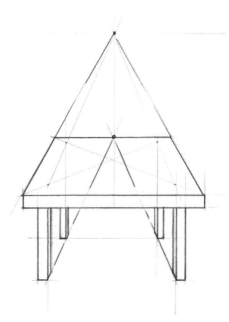

6 Ignoring a vanishing point

This L-shaped building is drawn in two-point perspective. The left-hand gable slopes down, with the far corner lower than the near one. On the right-hand gable, this vanishing point has been ignored and the far top corner looks the same height as the near corner. If there is no obvious line connecting two points, create a temporary one by bridging the points with a pencil to check the angle at which the building slopes.

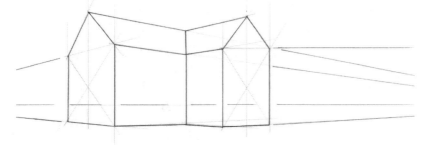

7 Badly placed figures

When we create a perspective drawing, we create the illusion of depth. Wrongly placed figures can look incongruous and out of place. The man further down the platform is exactly the same height as the nearer figure. However, because he doesn't obey the converging lines to the vanishing point, he looks like a giant. To place figures convincingly in a scene, place one near an object of the correct scale like a doorway or window, then project converging lines back to the vanishing point. This will help decide the scale of people further away.

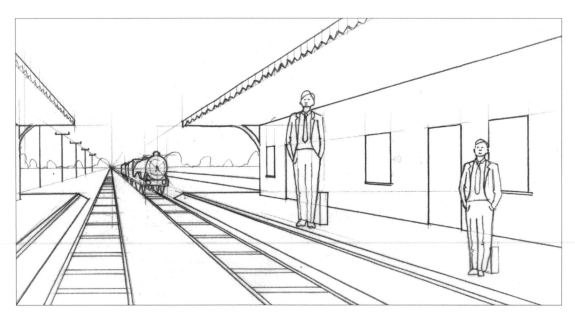

8 Everything the same line thickness

Vary the line thickness when drawing, generally adding thicker lines to nearer objects and fainter lines to far objects to create a feeling of depth and aerial perspective.

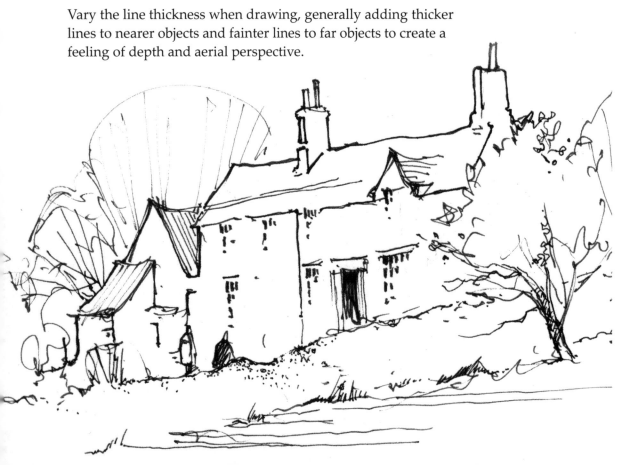

9 Unhappy coincidences

This happens when horizon lines are added in the wrong place. The table viewpoint shown here is such that the horizon line intersects exactly where the top surface is, robbing us of a view in perspective of the top of the table. It is also presented at an equal angle, hiding the far leg.

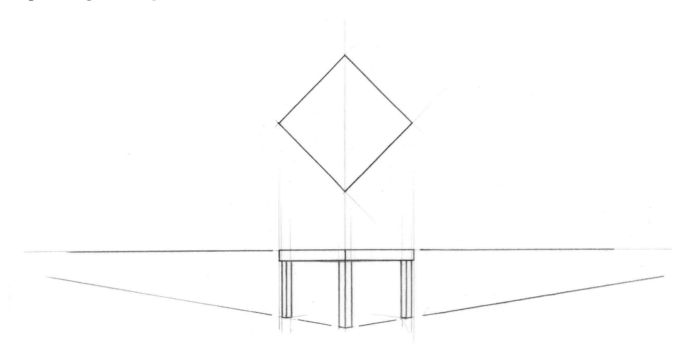

This building has a horizon line which is the same height as the guttering. The gables appear level and the scene loses the realism that could be achieved with a properly positioned horizon.

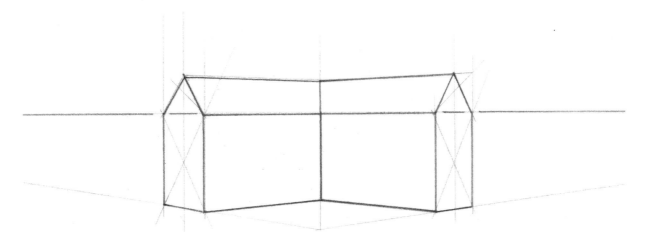

Perspective absurdities

I have taken the liberty of drawing a modern version of Hogarth's *Satire on False Pesrspective*, an engraving completed for perspective teacher, Joshua Kirby, in 1754. Hogarth inscibed his engraving: 'Whoever makes a design without the knowledge of perspective will be liable to such absurdities as are shown in this frontispiece'. I have added some of the mistakes mentioned previously plus a few less common ones.

1 The man's fishing line in the foreground crosses the one held by the man in the distance.

2 The sign is fixed to two buildings and the beams show no difference in depth.

3 The sign is overlapped by the distant trees.

4 The man walking across the far hill is having his drink filled by the man leaning out of the upstairs window of the house.

5 The crow perched on the tree is massive compared to the objects next to it.

6 The lighthouse appears to front the water, but both ends of the building can be seen at the same time. The distant land disappears behind the lighthouse tower but does not reappear.

7 The left water horizon curves downhill.

8 The man in the boat by the bridge is looking at the other boat in the distance, but his view points to the bridge abutments.

9 The reflection of the bridge in the water is a reversed drawing and not a true reflection.

10 The pony and trap on the bridge are too high and should be obscured by the bridge ramparts.

11 The arches under the bridge are not semicircular.

12 The right-hand arch meets the water higher than the left-hand end.

13 The far building, though seen from below, shows the top of the roof, as does the lighthouse.

14 The barrel near the fisherman curves incorrectly at the bottom.

15 The barrel on its side appears to be on lower ground than the others. The opening is circular and not an ellipse and the base inside the barrel should be visible.

16 The tiles the fisherman stands on have a vanishing point that converges towards the viewer.

17 The trees obscuring the sign get larger as they get further away, as do the cows walking down on the left.

18 You can see into the top of the chimney on the tall building. The roof line appears to converge to a vanishing point in the foreground. The windows don't follow the lines of the converging roof.

19 The boards on the near shed have a vanishing point that changes as they near the floor.

20 The line of the river bank does not appear in the bridge arch.

21 The boats are drawn incorrectly. The angle of the near boat would not allow the far side to be visible. The boat near the lighthouse shows too much of the interior for that viewing angle.

22 The shadow of the fisherman in the foreground is in a different direction when compared to other objects in the scene.

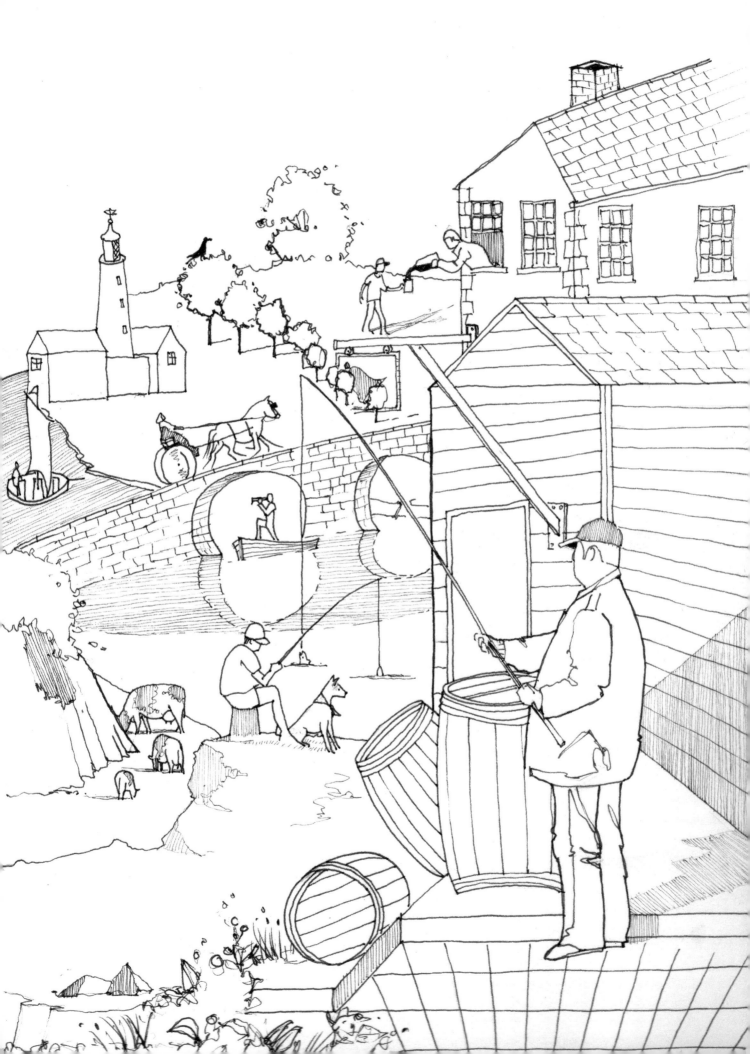

Beyond the rules

There is far more to perspective than applying the rules as described so far, and it is essential to learn to draw what you see. I do not normally plot out vanishing points and horizons, although I am conscious of their presence and how they affect what I draw. Line work forms a large part of my drawing. The pen tip stays in contact with the drawing surface nearly all the time I'm working. I work quickly to create flow, fluidity and expression in the line work.

Below are four drawing techniques that greatly aid artists to draw what they see. I have found that combining all of them helps to produce inspiring sketches and impressions of a scene within a very short period of time.

CONTOUR DRAWING

This is probably one of the most challenging systems to learn and I can remember avoiding it in favour of easier ways. These days it forms a major part of my sketching routine, combined with other techniques.

When we draw, we habitually break the scene down into individual items and then proceed to draw each object in turn. Contour drawing is essentially following edges, where no object has priority. We may start at a point of interest and then work outwards from there, letting the pen go in any direction it likes. Initially, this way of working is best tackled slowly and carefully. It relies very much on taking references from what has already been drawn. Too much enthusiasm working in one direction can result in nothing matching up as you return to your original starting point. This way of working is useful for drawing what you see, rather than what you know, as it bipasses some of our pre-conceived notions about how perspective behaves within a subject (see below).

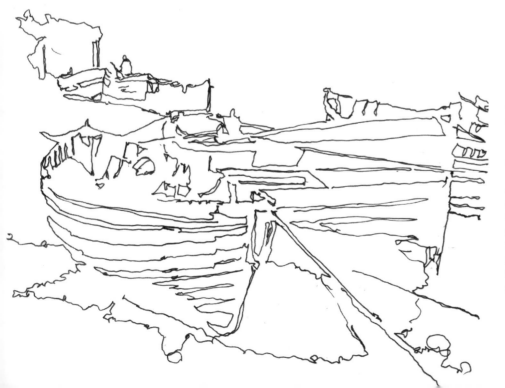

This entire scene of moored boats is drawn with one continuous line, and concentrates more on the interior of the vessels rather than the outer edges in order to create a more interesting drawing. One habit that is difficult to avoid when using this method is to outline everything. This is known as external contour drawing and results in very uninteresting work. Concentrating on the interior edges produces better results. Contour drawings should always look partially finished. A good test is to view your work upside-down to see if the image becomes more difficult to resolve.

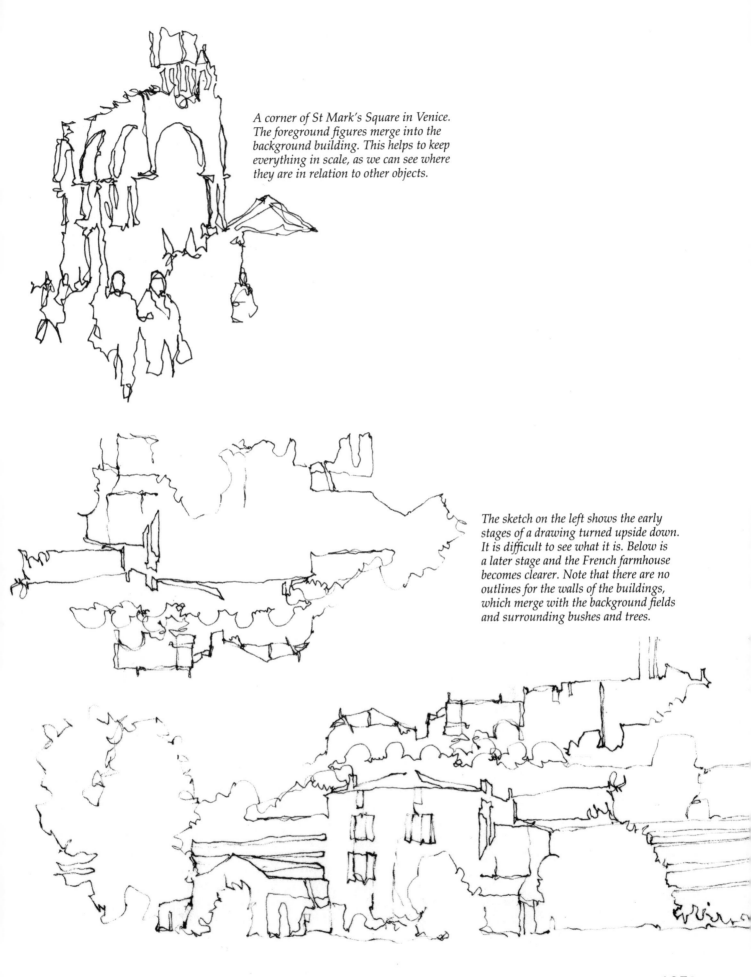

A corner of St Mark's Square in Venice. The foreground figures merge into the background building. This helps to keep everything in scale, as we can see where they are in relation to other objects.

The sketch on the left shows the early stages of a drawing turned upside down. It is difficult to see what it is. Below is a later stage and the French farmhouse becomes clearer. Note that there are no outlines for the walls of the buildings, which merge with the background fields and surrounding bushes and trees.

SPEED SCRIBBLE

Pareidolia is a talent most of us have: the ability to see images within abstract shapes, such as when we see a man in the moon or dragons and lions in clouds.

I scribble randomly and lightly on a drawing surface with a fibre-tipped pen and then look for shapes within the marks.

In this scribble (left), I had the impression of a couple seated at a table having drinks. After reinforcing the edges, I looked around for more figures, bearing in mind that all of the seated figures' heads needed to be level. This was then quickly expanded to sun canopies and a waiter standing in the background. I find this a very satisfying way of working and a good 'warm up' exercise for the mind.

This is a coastal headland dotted with houses. As it was complex, I used the same method as described previously, firstly scribbling a random impression of the view in front of me. Within these marks I was able to find and define the shapes of the buildings. As there are no defined edges, the scene looks acceptable and appears to conform to perspective rules.

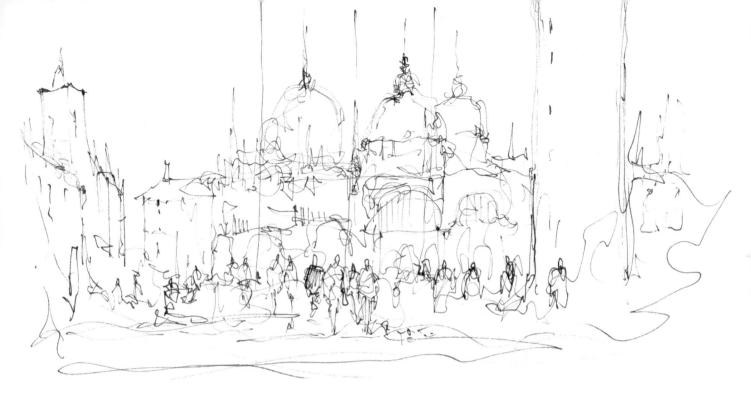

Complex subjects such as this busy view across St Mark's Square in Venice can be tackled using this method.

Cottages at Simonsburn

This drawing of cottages in Northumberland, UK, is another subject drawn very quickly, but it is more refined. Again, edges are built up from multiple-line scribble, which tricks the eyes and helps the viewer to 'see' the correct edges.

BLOCKS OF TONE

If we move away from line work and concentrate on the abstract shapes created by tone and shadow, subjects seem to take on a solidity and form that makes them easier to see and draw. Half-closing the eyes eliminates most edges in a subject and also makes it easier to see the tonal differences.

This sketch (above) was completed with no outline, just adding different shades to each surface using a 3B pencil.

This sketch (above) was done with a 3B pencil. I gave it a narrow tonal range to produce an atmospheric scene.

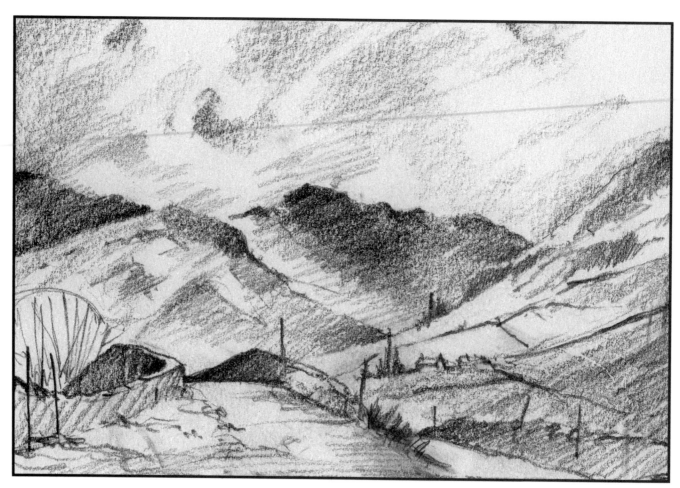

This is a more complete sketch (above) with greater differences in tone. At the end of the drawing, I added a few edges to sharpen up the scene.

Smaller subjects can be tackled very quickly, giving a flavour of the balance and layout of a composition.

NEGATIVE SPACE

Negative space or abstract space drawing is probably one of the most successful alternative ways of getting perspective right. Imagine taking a picture of a chair and cutting out the chair with a pair of scissors. Throw away the chair and draw the pieces of paper surrounding the chair. A good negative image can be produced that obeys the rules of perspective (see right).

This way of working also makes it easier when drawing circles and ellipses. When drawing the cart shown below, I first concentrated on drawing the gaps in the spokes of the wheels (below, top) and then on moving outwards to draw the rest of the vehicle (below, bottom).

COMBINING SYSTEMS

Street scenes going to a vanishing point can present a challenge when drawing. Concentrating on a few big shapes such as the sky and roadway helps to overcome our preconceptions of the scene. I like to add a rough outline frame to the sketch, which helps me to judge the exit points of converging lines within a scene. In the scene below left, I've also linked objects to create some new abstract shapes, connecting the building on the left to the pathway.

Often I use abstract shapes when starting a drawing just to get the perspective right, and then switch to a fast, scribbly form of line drawing with a pen. Finishing off, I add tone and shadow to the buildings to complete the sketch (below right).

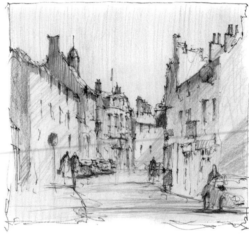

Highcross Street, Leicester, UK.

Working all systems together is a good way of quickly producing a satisfying sketch. Often the shading can be applied away from the scene if the weather isn't too good, making this a very fast way of working. I find that the more complicated the subject, the more line work and scribble I add before applying shade, as shown in the picture opposite of St Mark's Square, Venice. This is a very flexible way of working and also works well with much simpler drawings like the one opposite, top.

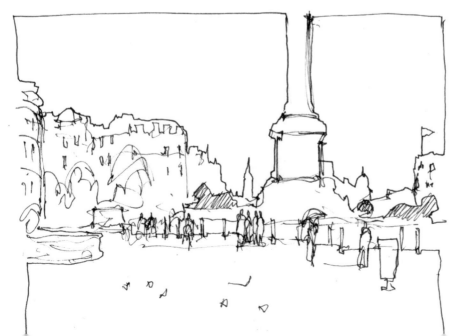

In this picture of Trafalgar Square, London, Nelson's Column divides the sky into two good shapes. This helped me to get the perspective of the distant buildings when I drew them. The foreground shape helped me to position signs, people and the edge of the fountain on the left.

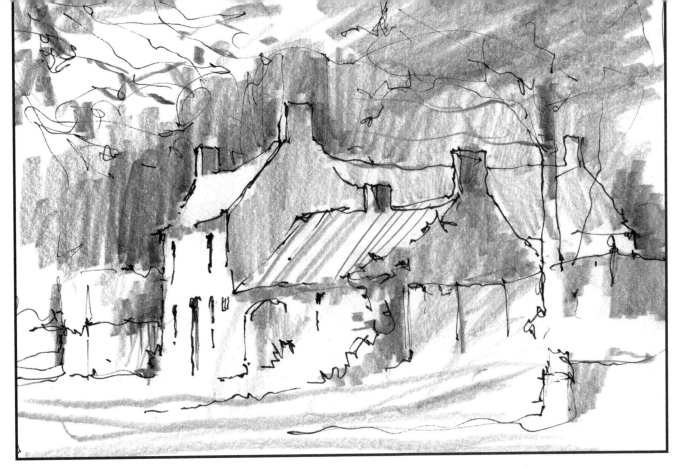

Hoby

In this simple scene in Hoby, Leicestershire, only a little line work and scribble was applied before I added the shading.

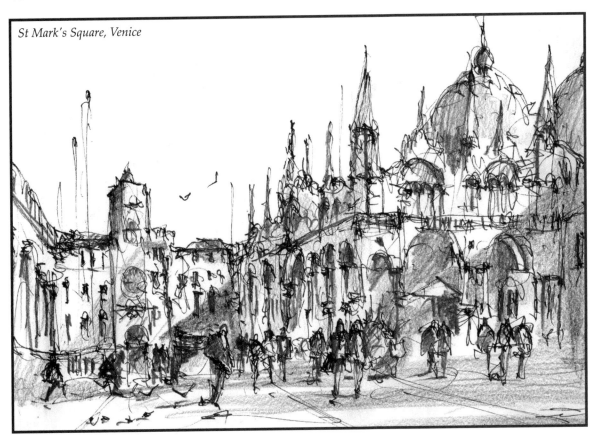

St Mark's Square, Venice

Index

Angle 19, 33, 36, 40, 42, 43, 52, 54, 56, 68, 76, 98, 99, 101, 102
Animal 28, 64–67, 68
Architectural 7, 10, 94

Boat 28, 59, 68–71, 77, 83, 84, 102, 104
Box 21, 36, 37, 38, 40, 45, 55, 62, 64, 65, 69, 70, 71, 81, 95
Bridge 16, 18, 29, 66, 78, 79, 88, 102
Bristol board 18, 94
Building 9, 16, 19, 25, 26, 30, 32, 33, 34, 35, 39, 41, 42, 43, 44, 45, 50, 51, 52, 53, 56, 57, 61, 66, 70, 71, 72, 73, 74, 75, 76, 82, 88, 89, 93, 94, 97, 98, 99, 101, 102, 105, 106, 110

Chalk 18, 20, 26
 Conté 18, 19, 26
Charcoal 12, 13, 16, 18, 19, 20, 26
Circle 54, 55, 90–91, 109
Cloud 9, 31, 52, 53, 80, 81, 82, 83, 84, 106
Composition 25, 30, 57, 74, 95, 108
Construction line 44, 52, 53, 90, 95
Contrast 28, 73
Converging lines 8, 26, 28, 34, 44, 51, 54, 64, 66, 67, 71, 88, 100, 110
Cube 40, 50, 91
Curve 6, 10, 19, 23, 51, 59, 68, 74, 78, 86, 87, 90, 94, 95, 97, 102

Ellipse 19, 58, 90–91, 92, 93, 94, 102, 109
Eyeline 36, 38, 40, 41, 43, 46, 48, 50, 51, 52, 54, 56, 60, 61, 64, 65, 66, 70, 86, 87, 93, 94

Faces 63, 81
Field 57, 88, 95, 105
Figure 8, 28, 29, 34, 38, 39, 48, 60, 61, 62, 66, 73, 76, 84, 93, 100, 105, 106
Focal point 30, 57
Foreshorten(ing) 32, 40, 63, 65, 68, 98
Freehand drawing 6, 22, 44, 90, 91

Guideline 9, 19, 28, 37, 77, 79, 82, 83, 84, 85, 90, 95
Guttering 33, 41, 43, 56, 98, 101

Head position 35, 36, 52
Highlight 18, 26, 57
Hill 29, 31, 102
Horizon 34, 41, 54, 60, 70, 72, 80, 82, 84, 86, 96, 98, 99, 101, 102, 104
House 41, 43, 51, 52, 53, 72, 73, 74, 98, 106

Ink 7, 14, 15, 17, 18, 21, 22, 23, 24, 25, 26, 29, 60, 61, 72, 75, 94

Lake 13, 16, 18, 29, 31, 88, 112

Landscape 6, 21, 28, 30, 33, 34, 49, 64, 65, 66, 86, 87, 88
Light direction 72, 75
Light source 72, 73
Line of sight 9, 35, 55, 63
Line work 14, 21, 22, 23, 29, 72, 104, 108, 110, 111

Mannequin 60, 62
Measurement 10, 32–33, 37, 98
Measuring 21, 32, 33, 37, 44, 49, 62, 74, 76, 77

Paper 7, 16, 18, 19, 20, 21, 24, 26, 33, 35, 39, 41, 44, 46, 50, 52, 57, 65, 67, 72, 78, 85, 86, 89, 90, 96, 99, 109
Pen 6, 7, 14, 15, 17, 18, 22–24, 26, 29, 38, 49, 61, 75, 94, 96, 104, 106, 110
 Dip 7, 14, 15, 23, 24, 26
 Drawing 6, 15, 17, 18, 22, 23, 29, 38, 49, 94
 Fibre-tipped 15, 22, 23, 38, 49, 75, 94
Pencil 12, 13, 18, 20, 21, 22, 25, 26, 28, 29, 30, 31, 33, 37, 49, 57, 60, 80, 90, 94, 96, 98, 99, 108
 Carbon 12, 13, 18
 Charcoal 12, 13, 20, 26
 Graphite 12, 13, 18, 21
Perspective
 Aerial 28, 31, 34, 73, 88, 100
 Curved 19, 90–97
 Curvilinear 95–97
 Linear 8, 94
Photograph 6, 30, 37, 44, 51
Picture plane 32, 35, 36, 40, 50, 70
Proportion 32–33, 38, 41, 60, 62, 65, 66, 70
Putty eraser 12, 16, 19, 26, 31

Reference 38, 42, 48, 60, 62, 65, 67, 71, 72, 78, 98, 104
Reflected light 73, 79
Reflection 16, 31, 51, 76–79, 86, 102
Renaissance 8, 34
River 16, 30, 76, 78, 86, 87, 96, 102
Road 16, 22, 28, 37, 45, 56, 66, 74, 86, 87, 88, 96, 98, 110
Roof 42, 43, 52, 75, 76, 89, 98, 102

Scale 8, 19, 21, 28, 29, 30, 32, 33, 38, 44, 60, 64, 67, 71, 100, 105
Sea 60, 80, 82, 84, 85
Shade 12, 13, 20, 21, 23, 24, 25, 28, 29, 30, 32, 49, 69, 72, 73, 79, 90, 108, 110
Shadow 6, 17, 22, 25, 26, 30, 72–75, 79, 102, 108, 110
Sketch 12, 16, 17, 21, 25, 28, 30, 33, 54,

56, 57, 58, 59, 60, 72, 74, 75, 80, 85, 86, 88, 96, 104, 105, 108, 110
Sketchbook 18, 31, 72, 86
Sketch marker 17, 24
Sky 9, 16, 31, 51, 71, 74, 80, 82, 84, 110
Sphere 90–91, 92
Station point 55, 58
Stairs 89, 102
Steps 6, 66, 89, 97

Techniques
 Blend(ing) 16, 19
 Contour drawing 104
 Cross hatching 23
 Hatching 23, 29
 Lift(ing) out 12, 16, 19, 30
 Scribble 106, 107, 110, 111
 Shading 12, 18, 19, 30, 31, 73, 81, 86, 91, 110, 111
 Stippling 24
 Vignetting 16, 59
 Wash 22
Texture 18, 23, 24, 26
Tonal scale 21, 28, 30, 33
Tone 12, 17, 18, 20, 21, 23, 24, 25, 26, 28, 31, 33, 72, 86, 108, 110
Tree 7, 16, 22, 23, 25, 26, 29, 30, 45, 48, 49, 74, 84, 86, 102, 105

Vanishing point 8, 19, 20, 28, 30, 31, 33, 34, 35, 36, 37, 38, 40, 41, 42, 43, 44, 45, 46, 48, 50, 51, 53, 54, 55, 56, 58, 60, 61, 62, 63, 64, 65, 67, 69, 70, 71, 72, 78, 82, 84, 85, 86, 88, 89, 93, 95, 96, 98, 99, 100, 102, 104, 110
Vehicle 16, 37, 38, 45, 109
Viewpoint 8, 11, 32, 36, 43, 62, 68, 69, 75, 88, 98, 101

Water 17, 52, 76, 77, 78, 79, 83, 85, 86, 102

Old Market Hall, Ambleside, Lake District.